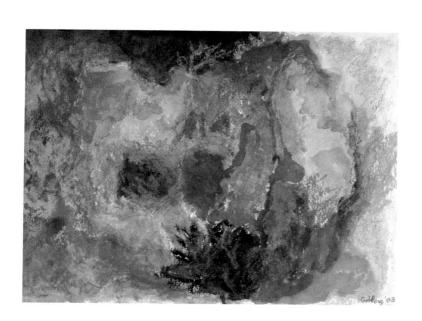

LIVING COLOR

PAINTING, WRITING, AND THE BONES OF SEEING

NATALIE GOLDBERG

STC CRAFT | A MELANIE FALICK BOOK NEW YORK

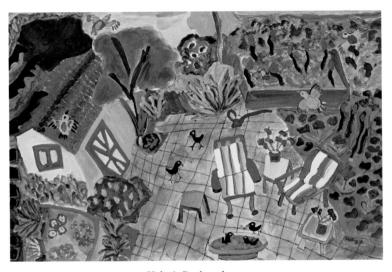

Helen's Backyard, 2013

FOR HELEN PARK BIGELOW WHO LOOKS LONG AND DEEP AND SLOW

INTRODUCTION 8

HOWIPAINT 14

LESSONS ONE & TWO 28

HANGING ON TO A HERSHEY BAR 30

LESSON THREE 37

WHEN PAINTING BECAME A JEWISH THING 38

LESSON FOUR 42

PAINTING MY FATHER 44

LESSON FIVE 56

TWELVE PAINTINGS IN EUROPE 58

LESSONS SIX, SEVEN, & EIGHT 62

THE SOURCE OF MY WRITING 64

LESSONS NINE & TEN 71

AT THE HOTEL SPLENDID 72

LESSONS ELEVEN & TWELVE 78

AT CÉZANNE'S STUDIO 80

LESSONS THIRTEEN & FOURTEEN 84

AT THE MUSÉE MATISSE 86

LESSON FIFTEEN 92

MATISSE IN NEW YORK 94

LESSONS SIXTEEN & SEVENTEEN 105

WRITER MEETS PAINTER 106

LESSON EIGHTEEN 119

BEYOND FORM 120

LESSONS NINETY & TWENTY 138

WALKING THE EDGE 140

LESSONS TWENTY-ONE & TWENTY-TWO 156

GALLERY 158

ALSO BY NATALIE GOLDBERG 190

A NOTE ABOUT THIS EDITION 191

INTRODUCTION

NOW THAT PEOPLE know I paint—I've included my artwork in books I've written, made public my darling pleasure—they not only want to attend writing workshops, they also ask me when I will teach painting. I jokingly say, Never. But if they pay close attention, I'm teaching painting all the time when I talk about writing.

Writing is a visual art. You want the reader to see what you are saying. You can't say, I love it, and expect the reader to know what you love. Instead you have to tell her how the mountain looked at dusk, the heavy creases seen from a distance, a canyon leading to a blue lake, how you knew there was water by the line of green cottonwoods, how the clouds gathered behind the twin peaks, a summer storm, and the sunset glazed the flanks of the mountain with the color of watermelon juice.

Now draw it.

But I don't know how, you say.

People used to tell me that all the time about writing, too.

First, you need to understand that writing and drawing are natural human endeavors. Trees, apples, sauerkraut jars, cars, tables, lions, dolphins—none of these write or draw. Only human beings do. Even twenty-five thousand years ago, prehistoric mortals left images on the walls of caves deep in the earth. I had the privilege of visiting Peche Merle in Cabrerets, France, walking down many flights of stone stairs into dank, dark grottoes. We turned a corner and behold,

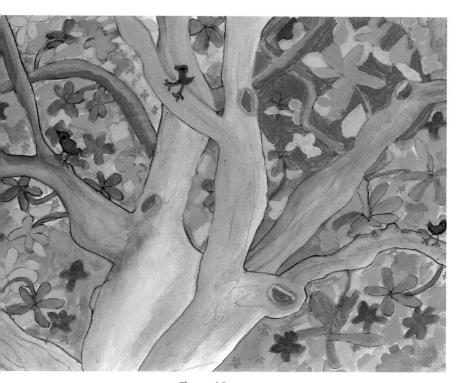

Tree and Stars, 2006

two spotted horses etched on the craggy wall. Most moving was the image of a five-fingered human hand pressed above one horse's back—the artist's signature, his greeting ringing out through the long lineage of centuries. Hello. I was here. This drawing is a testament.

Isn't that what we all want from writing and drawing? We have a need to express ourselves in this transient world. To stop time for a moment. To show how we see and feel before we are gone.

But let's get back to this feeling that you can't draw. Don't pay attention to your feeling. It's giving you the wrong information. Pick up a pen or a pencil—nothing fancy—and an ordinary piece of paper, even a sheet from your printer, and draw what's in front of you. Go ahead. The coffee in the cup with steam coming up at you, the spoon, the saucer. Draw the raisins, the blueberries, in your muffin. Color them in with your pen. Sketch the edge of the table, the napkin.

As you draw you might hear your mind thinking. Maybe you wish you had a cupcake, piled high with icing and jelly beans? Go ahead, draw that on the other side of the coffee cup. No one says you have to absolutely stay with the concrete—you get to capture your desires a little, too. Let's be honest: The cup you drew isn't a perfect circle anyway. Thank the heavens it's a bit lopsided. It has character. This isn't photography. And you've probably heard the rule: No erasing, no tearing up the paper. Accept the way it comes out. If you practice this acceptance, more will come out. Space and freedom will open up. You won't edit and crimp yourself even before you begin to explore.

Let's do another. Turn your head to the left. A lamp, a clock, a box of tissues on a wood table. Go ahead, draw them. I bet you'll have fun sketching the numbers on the clock. Can't fit all twelve? So what, don't worry about it. We already know a proper clock. This one is yours. Give no thought about it being perfect. This practice is not only enjoyable, it can also calm the mind by meeting what's in front of you with no interference. No good or bad, no judgment, no editor.

When Bob Dylan began drawing, he drew "whatever was at hand . . . the typewriter, a crucifix, a rose, pencils and knives and pins, empty cigarette boxes. I'd lose track of time completely . . . Not that I thought I was any great drawer . . ." Pencil pictures of a bell tower in Stockholm, a back alley near the Chicago River, a Washington, D.C. courtyard, backstage dressing room, rooftop bar, New Orleans walkway, Dallas hotel room, Buffalo neighborhood, motel pool, house on Union Street, house on Chestnut Street in New Bedford, the Statue of Liberty—Dylan drew a personal record, a narrative of what he encountered as he traveled. Drawing relaxed and refocused his restless mind and I imagine on endless tours it helped to order, stabilize, and relieve him of the tension of performing in different places night after night.

From simple line drawings you can begin to build a ground of being, a world of visual art in black and white. And then the impulse might arise—add red, add turquoise, orange, blue. Living Color is my memoir about traveling into the life of drawing and painting. In this updated and expanded volume I've added a lucky thirteenth chapter, documenting my further explorations into abstract art, and throughout the book I have included many new paintings for you to enjoy. In addition to sharing my own personal journey, I've also created twenty-two specific assignments for you, the reader, to begin discovering the visual expression of your environment-whether it be a landscape, portrait, cityscape, or a visual discourse with your mind. I have often juxtaposed assignments that are not obviously connected with the chapter you just read. My hope is to jostle your mind out of the ordinary, out of logic, and maybe after a moment of shock, snap you into feeling and creating from a non-rational place, where things are interconnected on a whole different level. Writing, painting, and drawing are linked. Don't let anyone split them apart, leading you to believe you are capable of expression in only one form. The mind is much more whole and vast than that.

Vietnam, 2003

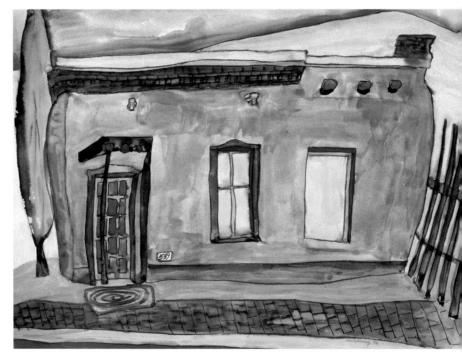

Blue House, Santa Fe, 1984

HOW I PAINT

WHAT I RECALL CLEARLY ABOUT THE FIRST TRUE PAINTING I EVER DID WAS THE FEELING THAT NIGHT THAT SOMETHING REAL WAS HAPPENING. I SENSED IT IN MY BODY, IN MY HAND holding the brush-a dash of yellow in the center, red close to the purple. I moved quickly. The sky outside was dark, the house silent. A drop of bright orange, more yellow, green. I wanted to paint the night, the windowpanes. My mind was big and calm. There was only the soft air of evening and the direct connection I felt with the pot of Johnny-jump-ups on the windowsill. Actually, there was no "I"; there were just distinct moments. A moment when I glanced up at those faces bobbing at the end of stems; another moment-yellow-that thought exploded in the hollow seat of my mind and my hand moved toward the tin of watercolors. My breath was a warm tunnel. I saw a glint of light on the water glass, on the kerosene lamp. I heard a moth bat at the screen. Black, I thought do I dare? Yes! I dipped the brush in water and into that round cake, then over to the paper.

I had let go and let something larger than myself take over. I stepped out of the way and let painting do painting. No Natalie and her bossy will, no fear of rejection, no desire to be Rembrandt. Just raw hunger. I loved those little flowers and wanted to capture them.

I loved the moment. Those pansy petals, the color on the page.

I painted that picture years ago, but recently I looked at it again. I was stunned. It had nothing of the grandeur I had imagined. It was a sweet painting of purple flowers on a windowsill. None of the night was there, not even any black color. Where were the drops of bright orange on the Johnny-jump-ups? Why were the dots of yellow so vague? Why had I chosen brown to fill in the windowpanes? Brown was meek, nothing like the flash and fever I remembered feeling. Was I mistaken about the experience? No, the experience was in me, different from the result. The painting I thought about was the vision in my head, the one I couldn't get on paper.

I was disappointed, but then I realized nothing I have ever created held the light the way a leaf did or caught the shadow in a white room. No painting I've done matched the peace I've felt at twilight or the feeling of loss I've experienced at bleached high noon in New Mexico. But I wasn't going to let that stop me. I was crazy about the wrong color sky and the heart-sinking beckoning of headlights on old cars. I painted for that terrible overused word that a writer should never utter: love. For that reason, I kept trying to catch up to the picture just ahead of me in my mind and before me on the porch.

TWENTY YEARS AGO, I was teaching part-time at an alternative elementary school in Taos, New Mexico. I borrowed one of those inexpensive boxes of kids' watercolors—an oblong case that snapped open, with six cakes ofprimary color and a ridiculous paintbrush with the bristles so awry they looked like cat's whiskers. I got a cheap sketch pad at the drugstore and I began to paint.

In those years, because I had little money and writing was my conscious love, it never occurred to me to buy a better brush or paints. I worked for two years with only the six basic colors (I kept borrowing kids' watercolor sets from the art teacher). This turned

out to be a great advantage: I learned color, how red looked next to orange, how it mixed terribly with green, how purple so often disappointed me and how to make turquoise out of blue and yellow.

I took my paints and the fountain pen I used for writing and I sat in front of my friend Gini's funky adobe higher up on the hill. I first drew that house with my pen and then colored the drawing in with my paints. I found out that the pen's ink ran with the watercolors. I liked that. I thought it looked "artistic."

My idea of "artistic" came from New Yorker covers and from the cartoon drawings inside. My family didn't subscribe to the magazine, but I must have read it in dentists' reception rooms. I was an inordinate eater of Hershey bars and Hydrox sandwich cookies and eventually had a cavity in every molar and bicuspid in my mouth. And my two front teeth were so buck I could shoot bubblegum through them. I spent a lot of time in dentists' offices, and as I waited for my turn to sit in the horrific chair, I paged through the magazines with the best pictures on the covers. Art was a whimsy of line and character; art was black contours, a wash of color and shade.

In those early Taos years, I developed a commitment that once I began a drawing, no matter how bad it was, I had to finish it. This understanding of commitment came from writing. Quitting in the middle of a writing exercise reinforced my internal critic, who said that I couldn't do it, or it was boring, or I was lost. But continuing to write—finishing—weakened my fear, my doubt, my disbelief in myself. Now with writing, this was all conscious. I wanted to be a writer more than anything else in the world and paid a lot of attention to it. I unconsciously carried this habit over to my painting. When I painted, I heard a voice calling from some far distant place: Finish that painting, even though you're certain it doesn't look right. Do it now. No whining. And I submitted. I continued to fill in detail as I sat in front of Gini's house, my back baking in the sun.

And as I worked, I realized I wasn't a great judge of my pictures

anyway. There wasn't any real good or bad. I simply merged with line and color. I stayed with what was and stayed away from evaluation. If there were four windowpanes on a house, I drew four. If Gini's dog, Jazz, walked by in front of me, I drew him in.

I noticed that the blue of my paints wasn't blue enough to get the intensity of that New Mexico sky. I painted the sky red instead. I painted Jazz yellow. He was a brown dog but yellow expressed him better. Color became fluid. Leaves did not have to be green. I added turquoise, then mixed blue with black and splashed on navy, which added a touch of melancholy—after all, it was the end of summer.

I was delighted one day to paint an adobe house blue. Stepping through the belief that I must paint mud brown, I experienced an explosion of energy and freedom. It was as though that blue paint were a sword slashing through illusion, bringing me into direct connection with the house's essence. Objects began to dance unhinged from their pigments. That man is green, those sheep are orange, that horse is scarlet. I wanted to shout with a new found freedom as I gazed around me from the hilltop where I had drawn the blue house.

Two years earlier I'd been a student teacher in a small town forty-five minutes outside of Ann Arbor. My supervisor told me repeatedly, "If you want to explain this"—she tapped the wooden desk in front of her—"you always have to go way out there and begin by explaining that." She pointed to the far corner of the room where a bookshelf stood. In other words, if you want to explain one thing, you have to begin with another; to talk of death, begin by speaking of birth. If you want students to write love poems, don't start by reading them the great love poems of the twentieth century and then say, "Okay, now you do it." Rather, read them a bunch of poems about tomatoes and parsnips and then surprise them: "Okay, now let's see if you can write a love poem." You could call this "the jolt method" of teaching—you surprise the students or stun them with contrast. I realized if I wanted someone to see the beauty I

saw from that hilltop, I'd have to paint the white sheep orange and give the horse the sun's hue. By going far away, by turning things inside-out, I could communicate what was right there in front of me. The supervising teacher was talking about metaphor as a teaching technique. I was learning metaphor through color on that hillside.

But mostly I was playing. Writing was the eldest son being groomed to succeed. I put all my effort into writing. Painting was a younger child left alone by an exhausted parent. Each day after I wrote and taught at the school in Taos, I could go out in the late afternoon and paint green chickens and cockeyed red goats.

Drawing the outline first with my pen was important. It was how I created structure for my painting. I remembered my college friend Carol telling me that as a young girl she colored in the blackand-white drawings of fashion models in the Sunday New York Times. Essentially, I was doing the same thing, but I used paint instead of crayons, and I drew the drawing myself. And the drawing was not just a skeleton to be fleshed out, like an outline in writing. The line was more like the thin wire some stores use to cut cheese. The wire often disappears from sight in the center of a cheddar wheel, but it still separates the wedges. The drawing in my paintings might become blurred, almost gone, in its contact with watercolor, but it still helped me create the shape of the painting.

When I was out scouting things to draw, I slowed down. I noticed doorknobs, light posts, the peeling paint of a gate. As I slowed down things became brilliant. Grass growing through a cement crack, a stop sign—its glowing yellow octagonal shape outlined in thick black—suddenly mattered, because I saw them. If a house was shabby, ill cared for, I was attracted to it. If a café had square linoleum tiles, odd wooden chairs, thick old plastic-covered booths, I wanted to draw it. And if I'd written well in that place earlier in the day, the good energy seemed to linger there and pull me back.

Many years later, when I lived in Minneapolis, I was depressed

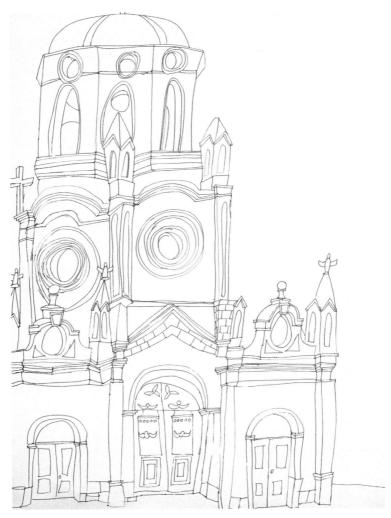

Ecuador Church, Drawing, 1990

Ecuador Church, 1990

at so many gray days. Then, one day as I was out searching for something to draw, I stopped and really looked at the gray of the stuccoed church on the corner against the gray of the Minnesota sky. Suddenly I appreciated that color. I saw how one gray could frame another gray. I also felt the gray Mississippi at my back several miles away and I knew if I drew a picture of that stuccoed church, I wanted the presence of that river in the picture just as I was feeling it, even if I never put a river in the painting.

I thought about what Hemingway said about writing: If you know a thing, it is in your work whether you write about it or not. So if I drew that gray church with the immense gray sky above and behind it and I *felt* that river—its movement and history, its connection to Mark Twain and Huck Finn, its unending dark water heading toward New Orleans, past old river towns, through the center of America itself—the river might not be in the painting but a sense of hugeness would be held in the color gray, a sense of time-lessness and the expanse of the fields that the river flowed through.

When I drew I wanted to express the friendliness I felt toward the thing standing in front of me. As I drew, it became a kindred spirit. With our human chauvinism we tend to think that chairs or saltshakers, buildings, mountains, or clouds, have no feelings, but what do we know? Everything is speaking if we listen. A rock just talks slower. It takes a hundred years for it to say one syllable. We're not around long enough to hear what it has to say.

I never erased a line I didn't like in order to put down what I thought was a more correct line. What's correct anyway? One of my friends, looking at my paintings, said, "Everything you draw looks like the way I saw when I took LSD." Just the act of trying to replicate a tree, a moon, an Oldsmobile out there on paper made me silly. Often when I painted I was laughing. I enjoyed the sudden awareness I had of a truck's face or a chair's wiggle. I got lost in the swirl of an old rag rug or the tilt of a lamp. I delighted in having a blue car

and a minivan stand on two wheels like bucking broncos right in the middle of downtown Minneapolis. And if I wanted something that wasn't there before me, I added it: birds in the sky, chickens pecking at the ground, yellow ducks crossing a street.

But it was important to have something concrete before me when I was trying to draw. It directed me outside myself. I couldn't get as lost in my mind as I could in writing; I had to connect with that chair, that tree, however ridiculous it seemed on paper. This was good. It kept me stable. Nat, there's a goat out there. You have something to do; go sit in front of that animal and draw it. Without that structure I just doodled all over my notebooks and phone books. But give me a goat—or a counter behind a chair and table with a ceiling fan above—and I created a picture.

Once I had the line drawing, I colored it in. I filled an old mayonnaise jar with water, dipped in my brush, and wet the small paint cakes. I wanted the truck red. I painted it red. It was not vibrant enough. I added orange. It began to vibrate and the black ink of my pen ran and blurred the edges. Here was where I stopped looking at anything except the picture before me. I forgot about the truck I had found an hour ago parked on a dusty road, which I had squatted in front of to draw.

At the beginning, for my first ten paintings or so, I actually took the paints outside with me; after I drew something, I painted it right there. I needed direct contact with the object in front of me to feel secure. After a while, I didn't need to take my paints when I wanted to draw. I'd bring the drawing home, place it on my kitchen table, and I'd listen. My mind was no longer up in the area above my eyebrows; my mind was my whole body. My hands moved the brush by their own natural force. I worked by instinct, heard cues from the objects in the picture and from my heart and blood vessels.

If green flashed through my mind, I painted a cup green; if blue flashed for a wall, I painted the wall blue. I listened; I listened. Some-

times I thought, no, don't do that! I stopped the rhythm and my painting got blurred. I then tried to paint the sky blue as I thought it should be. Well, it looked terrible and I tried to cover it with red. It made a sick maroon and my heart sank, but I'd been working for three hours on the painting already. I couldn't think "ruined." I kept going and took off from a maroon sky into a different relationship with the rest of the picture.

I usually worked around the whole surface of a painting, making sure colors were balanced. For instance, if I had a big hot-pink lawn chair smashed into the left corner of a painting, I'd make sure there was at least a hint of pink in the sky, as though the intense energy of that color in the lawn chair reverberated even into the heavens. Or I would put an equally powerful color on a big object over in the upper right-hand corner. A huge orange sun or a deep red airplane might do. The airplane would match the lawn chair's intensity and hold the picture in harmony.

Sometimes balance would come simply because I chose green, red, and purple for the dominant colors, and I'd make sure the whole surface was equally touched by all three. This did not mean that if there were two purple flowers there must be two red and two green flowers. It meant that the viewer had a sense of the greenness, the purpleness, and the redness of the picture. How did I discover this? After all, I wasn't schooled in art. I think I found my balance when I let go and allowed line and color to sing to me and let my own body echo back the song.

Balance was important in the drawing, too. It was how I got the objects in the drawing to relate to one another. Usually I just got excited about something, like a café scene, and zoomed into that: drawing chairs, their legs, seats, back supports, all dancing around a round table. Then I stopped and looked: Why, the whole thing was floating in space! I'd better give the furniture a floor to stand on, I'd think to myself. I'd draw square tiles for linoleum under the legs

of the table and chairs. Then I'd look up from the drawing. I was in a bakery. I'd pick up my pen again and border the upper part of the picture with a glass counter displaying muffins, cookies, breads. Then I'd add a storefront window at an angle to the baked goods counter to contain the picture. Now the square-tiled floor didn't run off the page. I'd have the delight of putting letters on the storefront. I managed to fit in the T-A-S of "Tassajara" and the B—the A was slightly obscured by a chair back—and K of "bakery."

This kind of balance was more natural to me than perspective. Perspective is a way to make objects "lie down" in a painting. In the Western world, we have a notion that things recede and converge as they go farther away. You're supposed to draw them smaller and at a certain angle to make them look distant. I remember learning one-point perspective in seventh grade in the one art class I took. The guide lines had to be made just so, and we used rulers as we did in math class. I did everything the teacher said and I was even interested in the "idea," how you made everything move back to a point in the distance, but it was sobering and made me quiet. Thirteen years later, when I began to draw in Taos, I think I intuitively suspected that perspective would put me outside the painting. I didn't want that. I wanted to get close to those tables and chairs, to jump in and feel myself dancing with them, even as I sat drawing them. I didn't want things to lie down; I wanted them to come forward, to beckon and call, to be noticed on the paper as I was noticing them in real life. I wanted the viewer to have a direct connection with the objects, to feel as happy as I was in their presence.

On the other hand, while the tables and chairs were dancing, I didn't want them to fall off the page. I had to anchor them to the floor and then anchor the floor to the surroundings. And maybe because I am a writer and like details, I wanted to get the place right. This was the Tassajara Bakery, for heaven's sake, the bakery that evolved out of the Tassajara Bread Book that Zen monk Ed Brown

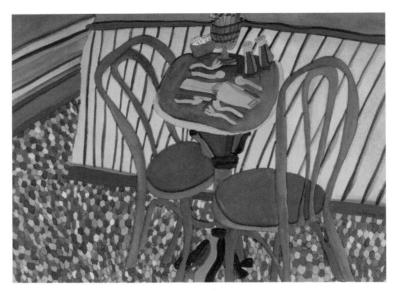

Serendipity, Manhattan, 1999

wrote and that I read in Ann Arbor when I was twenty-one and then made my first Swedish rye.

Before that I didn't know normal people could bake bread. At home, we always bought those fluffy white loaves in cellophane packages at the A&P. But when I called my grandmother in New York to proclaim my baking victory, she was dismayed. "Sweetheart, please, I'll send you the money. You shouldn't have to work so hard. Only poor people bake their own bread. We're in America now."

But I continued to make bread, and when I arrived at the San Francisco bakery ten years later, I recognized the loaves without even reading the signs. I knew about the magic of yeast and pastry dough and the sponge method for rising. The Tassajara Bakery was important to me. I wanted to acknowledge its existence with my painting.

Ten years after I began painting, I also began to create occasional imaginary scenes, such as the Tygers' little league game (although I

drew it while I was watching kids' games in a St. Paul park), or a picture called *Racing to Santa Fe* that I envisioned one night when I was late for an appointment and literally raced in my car from Taos to Santa Fe. In my mind, I was on a bicycle instead, enjoying the stars and the mountain air.

Someone once asked me to paint a picture they could give as a gift for a Jewish wedding. I made it up completely. I placed the picture in Israel with goats and sheep in the hills, a small gray temple-I quickly ran to the scriptures to copy out some Hebrew words to etch on the building. What those words mean escapes me now. I painted a huppah, the traditional wedding canopy, on the hillside, and had a pink car drive by with a "Just Married" banner waving behind it. Then, as though a glow lit inside me, I added a cemetery and erected gravestones bearing the names of the wedding couple and all the guests. My mind had suddenly taken a leap from Judaism to the Buddhist truth of impermanence and the knowledge that yes, indeed, someday we all will die. I was delighted by that Zen inclusion and felt it was a "big picture," capable of holding paradoxes and contradictions. However, the person who had commissioned the painting was horrified. I quickly returned her money and sent the picture down to my parents in Florida. I knew they'd be happy with a Jewish scene, whatever it was. They promptly hung it next to the television set in the living room and proudly pointed it out to their friends.

LESSON ONE

Find something messy, something you can't seem to control-the top of your desk or your clothes closet. Draw only a section of it. For example, on your desk, draw the Webster's New World Dictionary and on top of it a spiral notebook, or sketch an old cup filled with pens, pencils, and felt markers next to a bowl of paper clips. It's always fun, if you like, to stick in a few words. Draw an open journal on the desk and either write new words on the page-something you feel right now-or copy out some lines from an existing notebook. Yes, we are now manipulating the desktop a little. Just a little-for pleasure.

When you draw and pay attention to what is, it's a form of being present. This inspires the mind, makes it happy, and the heart wants to express more. Suddenly you add a vase of peonies, a cat, a half-eaten apple on the desk. Go ahead. But also remain true to what is. Don't vanish, cover up, what is actually concrete on the desk. What is concrete helps to ground the picture. Keep a foot in both worlds, the imagined and what's in front of you. Let the two worlds meet in your drawing.

Now find another chaotic jumble. Maybe your medicine chest or your garage. Take only a small section—where the skis are leaning on top of the snowboard. Draw that. Order your mind, make art out of the every-

day mess. Don't run from what feels overwhelming. It has energy.

Whenever I sit in front of something I'm about to draw, it always feels overwhelming. Then I pick up the pen or pencil and begin. That is the absolute trick: begin, start, take a first step. After that everything unfolds.

LESSON TWO

The writer Paul Auster has written all his novels, essays, and memoirs on a manual Olympia typewriter, and hanging in my hallway is a lithograph by Sam Messer of this typewriter. A piece of paper is in the carriage of the typewriter with the words, "Now is the time for all good men and women to come to the aid of their country," some letters a bit darker as though the author stomped harder on those keys. Do you see? There had to be some words in this picture.

Let's take a hint from Messer.
Draw something mechanical: a can opener, a wrench, a cement or cake mixer, a motorcycle, a water sprinkler. Open the hood of the car and draw its innards. Add some words somewhere on the page—the make, the manufacturer, a phrase that comes to mind—but don't be corny.

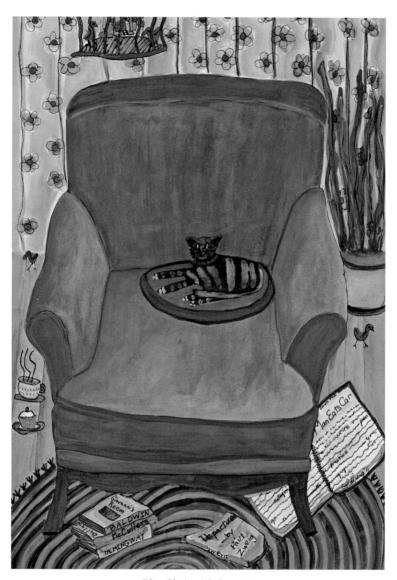

Blue Chair with Cat, 2011

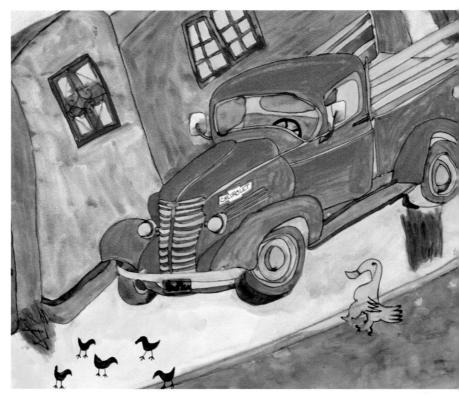

Red Truck, Santa Fe, 1984

HANGING ON TO A HERSHEY BAR

SALT CEDAR IS FLOWERING PINK AT THE TIPS OF ITS DELICATE BRANCHES RIGHT NOW OUTSIDE MY WINDOW, I ADMIRE THE BUSHES EVERY DAY, EVEN TAKE BREAKS FROM MY WORK AND sit outside in a blue chair and stare at them for long moments. Do I think of painting them? Never! Too hard. Too complicated. But when an old red car whizzes by the corner, longing rises in my chest. I want that on paper, and I know I am capable of fulfilling that task. The car was made by humans.

A part of me does not want to face the tangled green of nature. That part would prefer hanging out in a candy store, tightly gripping a Hershey bar and feeling the world secure around her. And I am sure it is this part of me, the young Natalie, who paints. And while adult Natalie is willing to face the cruelties and mysteries of life, the child wants to stay where she is forever. No moment but now. She does not want to develop or grow. She wants life easy and full of reliable pleasure.

Was my childhood that wonderful? No, but an element of it was. It had to do with my grandfather. Whenever I look at my paintings, I see him-my sweet, gentle, and quiet grandfather. I see him

in my painting of a large yellow duck crossing the road by a red truck, in the painting I did of a farm in Ecuador, in the apartment in Jerusalem, in the sun-drenched leaning Palm Beach houses, and in the hollyhocks in front of the pink adobe in Taos. I see something of well being, of contentment and acceptance in these paintings, something cheerful and unpretentious, something ordinary and elemental: comfortable chairs and couches, sunny days, no sorrow or loss, a sense of stability and well being. This is what my grandfather meant to me and what he gave me, and this energy is what I have transferred into painting.

He owned a big flatbed truck and every morning at 4 a.m. he drove it across the Williamsburg Bridge into New York City to pick up live poultry in wooden crates, and then back again to Brooklyn where he and his wife and older son, Manny, sold them at his market. I never actually saw the truck. My grandfather was out of the poultry business by the time I was born, the first child of his youngest daughter, but I imagined that truck in my child's mind, the front grillwork and the slow, ambling movement, balancing hens and capons in the back. I was six, about to begin first grade, when he and Grandma came to live with us, and it is that age—six or seven—that I feel I enter when I paint.

Sitting at the kitchen table, my grandfather ate all the leftover stale bread. Sometimes, the bread was so brittle it cracked in half. He saved paper napkins and used them again. He cleaned up the crumbs on the tablecloth. He drank three-day-old bitter coffee. Maybe that sounds stingy or tight, but I never experienced it that way. I felt in him a reverence for life, a kind tenderness and humility. He never made me eat the things he did and often in the morning he made my bed before I got a chance, and then cheerfully and quietly washed the dishes. One year, my sister and I received baby chicks for Passover. We lost interest in them soon after we named them Ginger and Daisy, but Grandpa cared for them in the garage.

Each day when we came home from school, he would be sitting in the driveway on a lawn chair in his brown pinstriped suit and slouch fedora, smoking a short brown stogie and reading the Yiddish newspaper. He'd look up when the yellow bus dropped us off in front of our house. "Hello, darlings," he'd say. "What did you learn today?" He thought school was a fine thing, so I did, too.

He owned a 1950 green Plymouth station wagon and I remember its round full trunk, like the behind of a stout pig, parked out front by the curb, near the thin maple saplings we planted in our new suburban development. In the middle of a boring Saturday, I could go to him. "Grandpa, could you drive us to Smile's five-andten to buy some doll clothes?"

"Certainly, sweetheart," I was sure he'd answer, "but first wipe the milk mustache from your upper lip," and he'd produce a folded handkerchief from his trouser pocket.

It was a wonder to me to drive in the tan back seat next to my best friend, Jo Ann Carosella, as though I had my own private taxi and chauffeur. My grandfather drove with care the five miles down Hempstead Turnpike, and we watched the hardware store, bank, and library go by in slow motion.

I think it amazed me to have an adult who wanted to please me, who had the time and patience to do something with me. It felt like a secret world, this time with my grandfather. My father was busy at work, my mother was concerned with mopping the kitchen floor and getting us off to school, and the love between my grandmother and me was different. She wanted me to learn the family's history and how to make blintzes. Acceptance and tenderness came from my grandfather. His world was simple, regular, predictable, and very comforting.

Each day at 5 P.M., before dinner, he took a walk around the block. He swung his arms energetically as he walked, because he had heard it was good exercise. The children in the neighborhood

would run out, calling, "Grandpa Cookie, Grandpa Cookie!" On several occasions he had given out vanilla wafers.

Every evening he listened to the news, and I would interrupt him to model the new dress my mother had bought me that day. I could always rely on his compliments. "Darling, you look lovely," and then I'd lean over—he had brought his lawn chair into the bedroom and placed it in front of the radio—and he'd plant a kiss on my cheek. When I was thirteen, I walked into his room to display a daring bikini and received the same assurance of my fine loveliness. He made me feel okay about my awkward, exposed body.

Only once did he admonish me. Dungarees, as we called them then, were coming into fashion. I tried a new pair on for him.

"Darling," he said, "young ladies do not wear these."

I took them off, told my mother to return them to Mays department store, and never wore jeans again—not so much because I cared about being a "lady" as that it displeased my grandfather.

His sense of humor showed itself when we would go out to a restaurant for dinner. As a busy waiter scurried past with his arms full of platters and dishes, my grandfather would look up, a small smile on his face, and say, "Excuse me, do you have a match?"

Often he said it too quietly for the waiter to hear, but it always brought peals of laughter from me and my sister, Romi. Once, though, in a diner, the waiter did spin around and spit out, "What was that, sir?" Romi and I grew tense. What would Grandpa do?

"You have a green grasshopper on your collar, young man," he quietly told him.

I see this slightly surrealistic humor in my paintings. Just yesterday I drew a view from my desk. When I looked at it later, it felt too stuffy. I added a framed portrait of a kid sticking out his tongue over the antique lamp.

There is a photo of me, my head just higher than the whiteclothed kitchen table, a barrette in my wispy brown hair, looking

over at my grandfather sitting in his paisley bathrobe, counting out change. He is rolling fifty pennies into brown bank paper. I am watching intently, because I earnestly want to learn how to do it. He would put the rolled pennies in his top bureau drawer where he usually kept loose coins. There was nothing else in that drawer but a white hankie he had folded neatly in the back. I often looked in that drawer. One day, I opened the drawer and there was a penny ensconced in a silver ring and it said Good Luck. I paused a moment and then took that lucky penny ring and put it in my brown corduroy pants pocket. I knew I was stealing-and from my darling grandfather no less!-but the urge was overwhelming. I don't think I ever returned it, and I have no idea what I did with it. It was my one transgression of his affection. Otherwise, with him, I learned what a normal thing love can be, an uncomplicated phenomenon in the regular order of things.

My grandparents went down to Miami Beach for several months each winter and over one Easter vacation we drove south through the eastern states bordering the Atlantic in my father's tan Buick to see them. When I first began to paint in Taos and I went to visit my parents, who had moved to Florida, I painted a number of those old Miami Beach art deco hotels. Few of those paintings have survived, but one is of the pink New Yorker Hotel, which was one block over from the beach where my grandparents stayed. The day after I drew it, I walked by only to see a huge crane swinging a wrecking ball against its lovely face.

I never think of drawing a new building. Only the old, the dilapidated, the uncared for and unnoticed draw my attention. Even in sparkling Palm Beach, I manage to find a fading, pink stucco house with a ragged blue awning and a creaky window balcony, or a poor-looking blue house with a gray door and an anemic palm tree leaning close to it. I like to paint what is marginal, what will not last. I wanted my grandfather to last. I painted my love for him

in every building I did, in every old car like his I saw in Taos or Minneapolis and in every truck I imagined he carried poultry in. And I threw chickens and ducks into my paintings because he worked with them all his life.

My bathroom paintings come from him, too. My sister and I shared a bedroom next to my grandparents' bedroom, and all four of us shared a small bathroom. I remember the light tap on the door. "Darling, are you finished in there?" my grandfather's voice would sift around the wooden doorframe. Well, no, I wasn't. I was trying on red nail polish. Very soon, there would be another tap. "Are you done, sweetheart?"

In that bathroom, enema bags hung from the shower curtain rod, false teeth sat in a glass by the sink, a hot water bag descended from the tub nozzle. There were foot bunion aids, salves for boils and arthritis, pills for indigestion and high blood pressure. I could see that bathrooms were a hot spot for adults. Later I felt an urgent need to paint them, especially if they had colored tiles, a rickety radiator, a claw-footed tub and cracked linoleum.

About fifteen years ago, in a dream, my grandfather came to me out of the grave with his face painted white and his body black. He bent low, whispering in my ear, "Tell our stories. Don't forget us." The kind of relationship I had with him, what he transmitted to me, has permeated my paintings, as it has my life—a silent layer of protection and humor in a chaotic world.

We think people die—and they do die—but my grandfather has lived with me all these past years while I painted, in the same way he lived in my life: a secret, quiet wonder, not the main attraction, like writing, but something that sustained my deepest work. He died when I was twenty-four. I began painting soon after that, and although he was physically gone, he flowed over into my colored pictures and never left me.

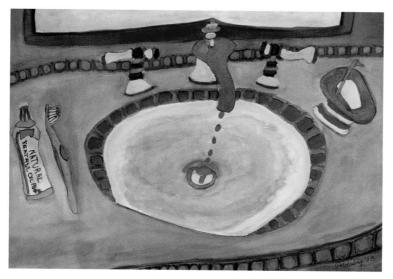

Santa Fe Sink, 2013

LESSON THREE

Open drawers and draw their contents. The silverware drawer in the kitchen, the cups and plates in the cupboard, the canned goods piled on top of each other in the pantry. Sketch the drawer in a barbershop or beauty shop; the money drawer of a cash register. Draw your son's, father's, husband's top bureau drawer. Whatever's there, maintain the objective, non-judgmental eye of the observer, the recorder.

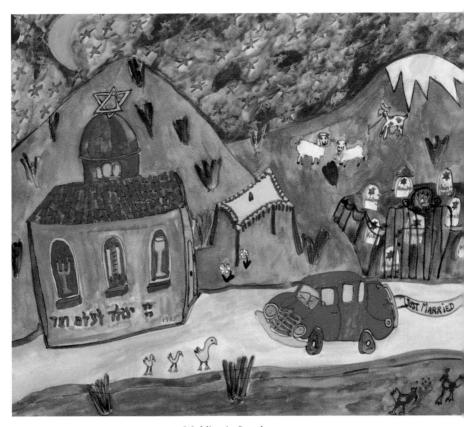

Wedding in Israel, 1985

WHEN PAINTING BECAME A **IEWISH THING**

UNCLE MANNY AND AUNT PRISCILLA DISCOVERED EUROPE IN THE LATE 1950S, FIRST SAILING OVER ON A LUXURY LINER, AND LATER FLYING SEVERAL TIMES, TAKING PHOTOS OF AMSTERDAM Rome, Florence, and Paris. Then they'd come home to their apartment in Flatbush and on weekends drive out to my family of barbarians on Long Island and show us their slides. There was the Eiffel Tower, the Seine River, my aunt waving from the doorway of the Uffizi Gallery in Florence, my uncle standing next to Michelangelo's David.

Munching on one of my grandmother's raspberry cookies, I would sit at the dining room table, poring over postcards of twisted women by Picasso and listening to Aunt Priscilla exclaim over van Gogh's colors. She pronounced "Gogh" like "Hock," putting plenty of breath on the "H." She'd learned how to do that when she was touring in Holland. I'd hear Aunt Priscilla tell my mother, "Why, Sylvia, this child [meaning me] must learn about him." I don't think my mother felt such urgency, but I thought Aunt Priscilla was right, as I gulped down a glass of milk and got a stomachache. I was glad to learn about him, and about Matisse and Cézanne, too.

Manny and Priscilla were like messengers from another world. I'd look at a picture of a Modigliani painting and then I'd look back across the room at my aunt, her high cheekbones and thin lips. I'd look at a postcard of a Chagall and then stare at the yellow silk pants that my uncle was wearing that Saturday. Not that the man in the Chagall painting had yellow pants, but they both had the quality of being wondrously strange and attractive to me. My comfortable childhood—bounded by the mailbox a block away, the school bus stop on the corner, Howard Johnson's on Hempstead Turnpike—was suddenly cracking open. There was another world—and it was related to me! Uncle Manny was my mother's older brother, and a doctor, my mother would remind me.

In the fall, Manny and Priscilla would drive miles out of their way to New England in order to see the "foliage." Aunt Priscilla pronounced that word for leaves like a high note in an opera. During summer vacation, their daughter Nanci came home from Brandeis University and sat on the redwood picnic table in our back patio and played "We Shall Overcome" on her guitar. She was the only person I knew going to college. Before she left for her freshman year, I remember her practicing the pronunciation of words like "dog." She said she wanted to lose her Brooklyn accent. What accent? Everyone in my family sounded alike.

On Passover, we visited their apartment at One Tennis Court. Every inch of their living room, hallways, dining room, bedroom, even their bathroom and my uncle Manny's reception room for his office, which was connected to their apartment, was covered with paintings and prints they had acquired on travels. The frames were ornate gold or mahogany. With the delicious smell of chicken and brisket wafting in from the kitchen, I asked why the number eleven over one hundred was penciled into the left-hand corner of a picture. My aunt came from the kitchen, leaned over and looked through her spectacles, wiping her hands with her apron. "This is a lithograph

by Daumier," she told me. And she explained how it had been made and what the numbers meant. She was delighted that I was interested in her world and she wanted me to understand. The fact alone that an adult took the time to explain something to me lit a light in my dark and ignorant world. Now I was proud to understand the numbers in lithographs. My aunt went back to cooking and I eagerly took in the next picture.

It was a framed old newspaper print and it had words I could read. It said, "Sketch published February 9, 1787, in Picadilly." Even my grandmother wasn't born then. In bigger letters was the title, Anticipation. The picture was of two bare-chested men, both wearing boxing gloves, about to fight. One man was in orange knee-length knickers. The other wore gold ones, had a much hairier chest, and he was about to land a punch on the face of the opposite man, who was wearing a white wig with a ponytail. Both were hefty and wore black shoes with buckles. There was some writing above each head that I could not read. I stared at that picture for a long time, trying to understand the title. I supposed that the "anticipation" was the man waiting to get punched, though he looked pretty stoic to me. I didn't think to ask about this one-I might have learned that it was a political illustration—because dinner was finally ready.

As I bent over the chicken broth and matzo ball soup, I surmised that painting was something good. And as I reached for a Barton's chocolate truffle at the end of the meal, I knew that art was a Jewish thing. Even Degas and Rouault had something to do with my religion, because they were there on my relatives' walls while we celebrated our holidays.

At that visit with Aunt Priscilla and Uncle Manny a seed was planted. From then on, I began to notice paintings-in books in the public library, even hanging in the beauty parlor, and in the waiting room when my father consulted a lawyer. The world of painting sprang up to illuminate my world.

LESSON FOUR

When you want to learn something, the best way is to go to a person who does it well and look at their work. If you want to write, study novels or short stories, poems, essays. The writers you read are your teachers. The same is true of visual art. You can't always see the original painting, but you can see copies of the painter's work. I usually take a leap and purchase an art book—or take one out of the library and spend a full evening looking at one painting after another.

I am particularly enthralled with Wayne Thiebaud right now. I turn the pages in his book, Wayne Thiebaud: A Painting Retrospective, and I find a painting of seven cakes in a window, one with a heart on top, one a layer cake, a Bundt cake, a cake topped with lemon sauce; a black scoop of ice cream in a cone; eight lipsticks, lined up in two rows; three gumball machines: a delicatessen counter with a shelf of cheeses, ham at \$1.09 a pound (this was painted in 1963 when commodities were cheaper), sausages and salamis hanging above: more cakes-wedding cakes on one counter, and below, rows of round two-layer cakes; five hot dogs in buns with mustard, each one slightly different. Each painting has shadows cast by the objectsa delight and a darkness. All of them feel particularly American, holding

our abundance, our sugar coating, and our yearning, hunger, desire.

I wanted to paint these objects too: Hamburger Heaven in Palm Beach, Florida served cherry pie with the berries dripping over the crust; their big unforgettable chocolate layer cake. And then in San Francisco, at a savory café, I drew their pastries on shelves. I don't know if I would have done these if not for Thiebaud. And, yes, I am copying his idea—this is how we learn. It helps us to develop our own style.

You know what to do. Draw a bag of potato chips, rows of candy bars, or mayonnaise or mustard jars. Our supermarkets are full of rows of objects to paint and draw. Draw a shelf of foods you love.

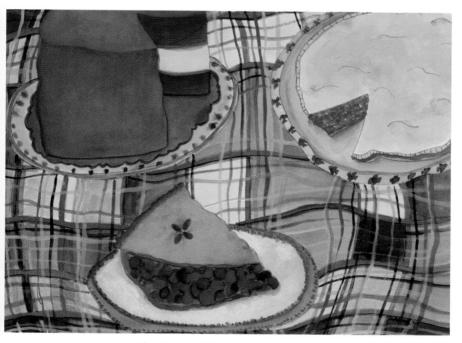

Three Sweets with Plaid Tablecloth, 2004

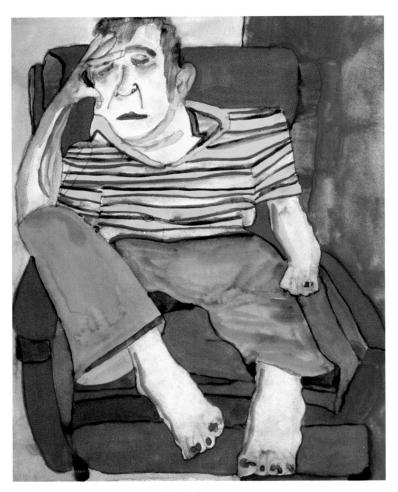

My Father, 1990

PAINTING MY FATHER

MY MOTHER WAS BEAUTIFUL WHEN I WAS GROWING UP. I REMEMBER HER THICK, BLACK, CURLY HAIR, HER SHINY COALBLACK EYES, AND HER LARGE WHITE TEETH AND DARK RED lipstick. I can even go way back to an afternoon as a young child when I still drank a bottle, lying back on a green blanket, the bare branches tapping at the window, my fingers entwined in the ecstasy of my mother's curls, those soft hands of hers, with the thick gold wedding band, caressing my chest. I think it was even way back then that I got the notion that love and good looks were somehow connected.

We were a family interested in beauty. When I got older, I thought my sister, Romi, was gorgeous and she thought I was. My aunt Rae, on my father's side, had a nose job and many suitors; Aunt Lil was notorious for her long legs. We learned early the Yiddish expressions "chena madala"—pretty little girl—and "mieskeit," a lemon, for someone who was not pretty.

Somehow, though, I have never chosen to paint my beautiful female relatives. The only family member I have ever painted is my father. He was the one person in our house who lived outside of sedate, middle-class values. He gambled; he went to the race track; he yelled and flung his fists wildly as he sat in his underwear, absorbed in the World Series on TV. He came and went to places

unknown to my sister and me. He didn't care about clothes, shopping, or cooking. He was a gap in my claustrophobic childhood.

He stayed in bed late on Sunday mornings, and my sister and I would run down the hall, fling open the door, and careen through the air, pouncing on top of him, screaming, "Chaaarge!"

My mother would yell from the hallway, "Girls, please, you'll hurt your womanly insides."

We didn't care. He grabbed us and we wrestled.

When my father taught me something—to swim, to play pool—he was dead serious. He'd yell at us if we made a mistake, oblivious that we were young girls and new at it. It was awful, but there was also something delicious about it. I had a taste of the tough, real male world. You played hard. You weren't a sissy.

I remember only once when he went food shopping, and I got to go with him. My mother had the flu and made a list of groceries for us to pick up. As soon as we entered Waldbaum's, he crumpled up the list, flung it in a wastebasket, and said, "Let's go!" We flew down the aisles, throwing into the cart all his favorites: canned sardines, kosher salami, a frozen pizza, kosher pickles, sauerkraut, cherry vanilla ice cream, saltines, and a Sara Lee pound cake. Every time he grabbed something off the shelf, he'd hold it up to me, and flick his eyebrows up and down, and I would convulse in laughter. I was wild to laugh. I was his best audience. It was exciting. We were in a conspiracy together.

I remember another time, when I walked into the kitchen after everyone had gone to sleep, and the light from the open refrigerator revealed my father standing there, drinking straight out of the cold-water bottle. That was a cardinal sin in our family. My mother repeated often that it would spread germs.

"Yup, I caught you." I pointed my finger.

"Don't tell," he said. "I love to drink from the bottey" (a term used in our family for baby bottles).

We both burst out laughing. And again I felt something split open, just a crack.

My father owned a bar in Farmingdale, New York. I often saw him in his white pressed shirt sitting at the breakfast table, reading the newspaper and lifting the white cup filled with coffee to his mouth. The Aero Tavern was five miles away. Some weeks he worked nights. At 5 P.M., he would be eating a T-bone steak with lots of ketchup before leaving. Again, he would be in his white, long-sleeved, button-down, freshly pressed shirt. When he came home, usually the sleeves were rolled half way to his elbows. He went to work six, sometimes seven days a week, no matter what the weather. I remember him bending over to put on heavy boots—the snow had drifted, no cars were running—to walk to work. Nothing stopped him. No type of weather, no ache or pain.

The first painting I did of him was in 1978, when he still owned that bar. My parents were out visiting my husband and me in Minneapolis, and one afternoon in early August, I breezed through the living room to the screened-in porch, plopped myself down in front of my father, who was on the porch swing, and began to draw him. I drew quickly, with no hesitation.

My mother leaned over when I was done. "Oh, Daddy won't like that. He doesn't look handsome."

I held it up. They shook their heads in unison.

"That's not me," my father said. "I'm good looking." I put the drawing away.

During that visit he said to me, looking down at the floor boards, "I've wasted my life at the Aero Tavern." He'd owned the Aero for thirty years.

I waited. Was he about to reveal his deep inner yearnings—to be a rabbi? A poet? An explorer?

He looked up. "I could have made a killing in the vacuumcleaning business." A month later I took the drawing of him out of a drawer. All I had to do was fill in with a little color the truth that was already there on paper. Contrary to my parents' opinion, I knew it looked like him, but the painting depressed me. I'd caught the sourness he felt toward life. I didn't want to think of my father like that, but in truth he did have a powerful, heavy energy and a certain bitterness, and there had always been fear mixed in with my excitement around him. Once when I was about thirteen, sprawled out on the back seat of the Buick, I sang a rock 'n' roll song about closing the door to temptation and not letting someone walk in. My father turned from the front seat—we were waiting for my mother outside the cleaners—and gave me a filthy sneer, as though I'd done something terrible. I immediately clamped down and shrank against the door. I had no idea what the song meant—I'd just heard it on the radio.

When I sat in front of my father on that porch in Minneapolis, at the age of thirty-one, I saw this bitter face again. My hand cut through with its own life and drew what it instinctively saw. *Ben, the Bartender* made me uncomfortable, so I simply stuck the drawing up in my attic, out of sight, and forgot it.

Two years later, having separated from my husband, I was depressed. My parents called me on the phone. When they hung up, my mother later told me that my father looked at her and said, "She's unhappy. Let's go see her."

They packed and the next day drove up from Florida—my father had retired and they had moved there two months earlier.

Again, during that visit, I painted him. This one I simply titled *Ben Goldberg*. He is wearing a navy-blue turtleneck sweater, a brown felt hat and a ruby ring, the one his mother, Rose, had given him forty years earlier and that he had never taken off.

This time, when I held up the drawing, my mother clapped her hands. "That's him! That's him!"

"No, it isn't," my father said. Then he cocked his head and smiled.

"Yes, yes, that's your look. Natli got it exactly right and those lips of yours—" my mother cried.

"I don't like the double chin," he said.

"So lose weight." She tapped his belly.

This one I was more comfortable with. It was his suspicious look, the one he used when he was about to say, "You gotta be kidding," or when he got going on how terrible the Beatles were, how they played their noisy music and his two daughters took off in the sixties for all corners of the country and never came back.

When I look at the painting now, I also see a lot of sadness. I don't think life turned out the way he would have liked, but I'm not sure what it was he wanted—to score at the races? To win the lottery? To not have his mother die of Parkinson's disease? He was raised as an Orthodox Jew, but when I was a child he often proclaimed his atheism. I wonder if he hadn't once believed, and God had somehow failed him. "Who would make a world like this anyway?" I could hear him say, feeling betrayed at an essential spiritual level. You work hard and then you die.

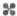

THEN I DID NOT paint him for ten years. By 1990, he was deep in retirement, and I drew him asleep in his TV chair, having snoozed off watching a golf tournament, wearing a casual striped polo shirt and loose pants. I intuitively knew I'd caught him and I tiptoed off.

In 1993, I sketch him again when I'm down visiting in Florida.

I say, "C'mon, let me draw you," and now he likes the attention. I imagine it feels to him like being a young child and your mother gently looking through your hair, touching the nape of your neck, hunting for ticks after you've been out playing in the woods. You are getting concentrated care from the one person you want it from most.

My father's brother and two sisters are all dead by 1993 and his daughters live far away. He is glad I am sitting with him. He can

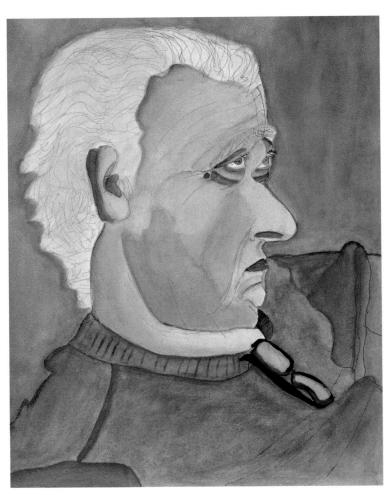

Profile, Ben Goldberg, 1998

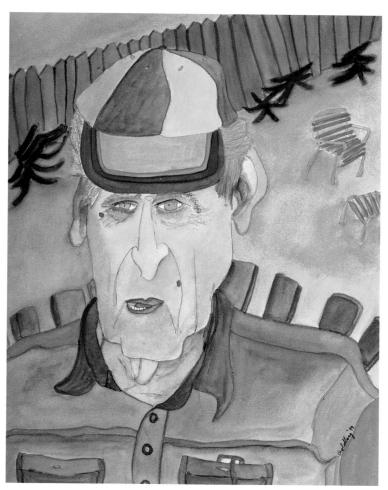

My Father Remembers the New York Dodgers, 1999

almost feel my examination of the edge of his ear with my pen.

The first one I draw I know is not him. My mother walks by and offers me butterscotch candies out of a china dish. I shake my head.

She leans over. "Naaa, that's not Daddy." She pauses. "Why don't you draw me?" she pouts.

I do another drawing. There he is, a vulnerable moment caught. I've seen that face before. It is the one I adore. It is self-reflective, a moment of recognition, usually followed by a sweet joke about himself. His shirt is open and you can see some chest hairs. His hair is longer now. He's been retired for thirteen years. He's softer, more liberal. He says he detested the Vietnam War. I don't argue with him. When it was happening, he'd talk to his cronies at the Aero about how we should nuke them into the Stone Age.

I remembered my world used to bewilder him. His essential understanding came from being a sergeant for five years during World War II. And I think though he says the war years were the best of his life—he got to travel, "see the world"—it is where the deep sadness and disappointment were finalized.

Jim Perlman, my poetry publisher, told me once that his father was one of the first Americans to liberate Auschwitz. Jim's mother said he was a different person when he returned. He never talked much when Jim was growing up, and the only thing that made him peaceful was planting and tending prize tomatoes in his garden. Later, I dedicated a poem to Jim. Part of it reads:

I didn't know
we were the daughters of night guns
That our blood fathers were killers
That the heart was torn out of us
in World War II
Came to graze in ice cream parlors
quiet cricket streets
years later
like nothing ever happened

The Aero Tavern, which my father bought with an army friend, and where he thought he wasted his life, was a result of those years overseas. He came home and didn't know what to do. Life was scrambled after the war. Men came back and wanted to settle quickly, put to rest what they had seen. He grabbed something he'd never done and knew nothing about and made a new beginning.

What I felt through my father was something scary, unfathomable, dark, also true and real about the world. When I sat in front of him to draw, my hand, like a diviner striking water, found some root source of suffering, though my conscious mind was not aware of it.

In the summer of 1994, my father and mother were due to visit me in Taos. This time I was prepared: I bought good watercolor paper and even invited some of my professional painting friends to take a gander at his face. We set up an afternoon at one of their studios. I called my father and told him. I knew he would be pleased. He loves contact with young people. In my forties, I was still young to him.

He joked on the phone. "It took a lot to make this face. It doesn't go cheap. I want to get paid."

When I picked my parents up a week later at the airport in Albuquerque, his right elbow was in pain. He couldn't straighten it out. I took him to the emergency room in Santa Fe, where my mother and I sat in the waiting room while a medic examined and taped his arm.

When it was over, I took them to a good restaurant for dinner, to cheer them up. My father ordered shrimp in garlic sauce with rice. His arm was in a sling and he thought shrimp would be easy to eat because he didn't have to cut them up. The restaurant served the shrimp with the shells on. My parents had never heard of anything like that. He was disconsolate. He couldn't eat without help.

36

AS THE WEEK went on, his arm felt a little better, but the seventhousand-foot altitude in Taos was hard on him. He wasn't hungry, he was tired, he felt disoriented. He wanted to go home. We canceled the painting session with my friends.

He's getting old, I told myself that night. This might be the last time he's able to come here. I sat down at my kitchen table. I felt everything drain from me. I always knew this would happen someday, but it was happening now, right in front of my face. And I couldn't do anything to stop it.

The next day, he felt a little better. I took them to an outdoor café facing El Salto Mountain in Arroyo Seco.

"Hey," he said, "I'll try eating a little."

While he ate, I took out my pad, but the first drawing I did didn't look like him. I couldn't touch with my pen how he felt, even though it was strong and thick in the air. The second drawing maybe had something, but I wasn't clear enough to tell right then.

A month after they left, I went camping along the Chama River by myself. When I got there, I hunkered down in a folding chair under a big cottonwood with the pad containing the drawings of my father, opened my paints, poured water from my canteen into a jar, leaned over, picked up a brush and began.

Though the second drawing did not quite look like him, I knew I had caught something there. The picture did not come easy and direct as it had with other portraits of my father. I sat for the whole day painting, and I felt an aching or a yearning—I'm not sure which—as I worked, something grinding deep inside of me.

That night, I put up the tent. I did not feel brave enough to sleep outside in my sleeping bag as I used to do. The sky was dark, immense, and I was alone.

The next morning, I ate some bread and cheese. I didn't bother to make a fire and cook oatmeal. I was eager and nervous to look at yesterday's painting. No, it wasn't finished yet. I began to work slowly. I painted the whites of his eyes yellow. The background was yellow, too. His skin had a green hue and his hair was purple. His

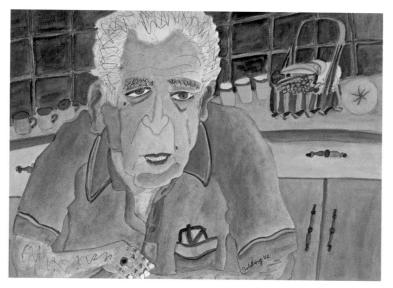

Last Painting of My Father, 2002

ears were outlined in green. I saw how tentative his lips looked. I felt they wanted to say something but didn't.

I took several breaks. I went swimming in the river. I read short chapters of Stones for Ibarra, by Harriet Doerr. Right from the beginning, it is clear that Richard Everton, the main character, will die in the end. The whole novel is an exquisite unfolding of that fact.

I was close to the finish of the painting. I leaned it against the base of a cottonwood, stepped back, and saw it. The man's face in the painting was full of fear. That's what I'd seen in my father's face that week. That's also what I'd felt.

I sat back down under the cottonwood. My father will die someday, I thought to myself, and we're both afraid. His picture had brought me close to him. I was once afraid of his darkness. Now I was afraid of his death.

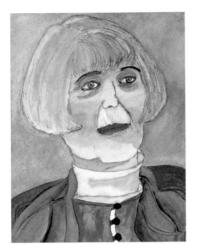

Madeleine, 1997

LESSON FIVE

Go to a café, a library, some place where people will be sitting for a period of time. Pick one person and draw them. They may bend down to read something or turn their head, but do the best you can. Don't get frustrated. Keep drawing. So what if you began frontal and now you have a good shot at their ear. Put the whole ear in. Your one portrait might have many angles. Picasso did it. Why can't you?

Now change places, sit in another seat. Face another direction. Draw another face. Keep practicing. Do ten portraits over several days.

Now that you've painted ten anonymous faces, ask a friend, a parent, a partner, a sleeping dog to sit for you.

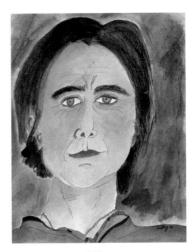

Michêle, 2002

Trust your lines. Don't erase. Look closely at the nose. How much higher up is it than the mouth. How far below the eyes? Look at relationship, the chin compared to the cheekbone.

Forget that this person in front of you might be your boyfriend and you think he is handsome. You are studying the forms and lines of a face—no good or bad.

You might be surprised with what comes out—unintentionally, unknowingly, you capture your friend's sorrow or grief, an aunt's despair, a lover's stress. Good. That's what gives life and depth to the face. Don't worry, those emotions were always there.

Now, if you like, add color. Apply lightly, then add more color. Experi-

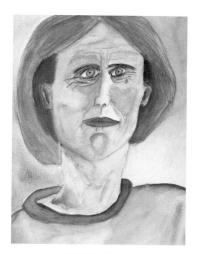

Kat Duff, 1997

ment. Don't be afraid to add vellow. purple, green to a face.

In 1996, I would meet with five other painters in Barbara Zaring's Taos studio once a week for two hours in the afternoon and draw a person who sat for us. I was in charge of finding the model each week. I loved that. I asked unusual people with interesting faces: Maria, the director of the Mabel Dodge Lujan House; my neighbor from Ohio, Samantha, who lived in a dirt hut and made jewelry; my plumber, Joe Hoar; Kat Duff, an astrologer; Jean Leyshon, a Zen priest.

We all had the same model, but each of our paintings looked completely different. We chatted as we worked. For me, a writer who works silently, this was heaven.

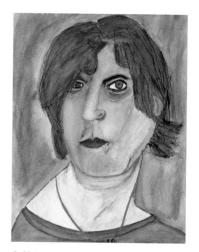

Self-Portrait: Sick of Picasso, Paris, 1997

Presently I am reading Man with a Blue Scarf: On Sitting for a Portrait by Lucian Freud by Martin Gayford. It's the journal Gayford kept for the seven months he sat for Lucian. who is considered to be the greatest figurative painter of our time and who is the grandson of Sigmund Freud. He cares about the particular in everything. During the time Freud was painting Gayford, he also went out to a stable each day to paint a skewbald mare's body from its shoulders back to the tail, but without the head and neck. At the stable he also painted a head portrait of an old gray gelding.

Reading this book is deep pleasure. It takes you into an artist's studio and you watch a portrait by a great painter unfold over time.

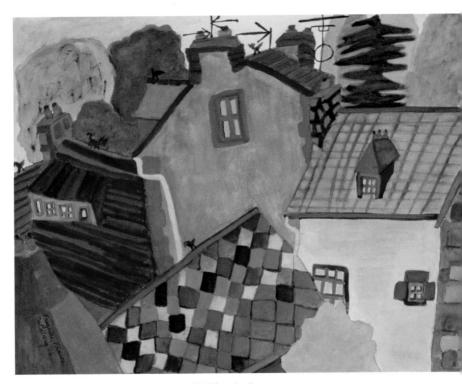

Small Village in France, 2007

TWELVE PAINTINGS IN **EUROPE**

THE FIRST TIME I WENT TO PARIS WAS WITH MY FRIEND BAR-BARA FROM NEBRASKA. I WAS THIRTY-SIX YEARS OLD. WE HAD A SMALL, CHEAP ROOM IN THE MARAIS DISTRICT, AT THE HOTEL Jeanne d'Arc, on the top floor where the ceiling was pitched steeply like the roof. We had to walk up ten flights of stairs; there was no elevator. The walls were papered in pink flowers, and I slept on a cot along one wall while Barbara lay in her bed in the middle of the room. The red-haired, high-complexioned owner of the hotel did not speak English, and I loved practicing my high school French, to her dismay.

"Avez-vous un vase?" I asked one afternoon, holding up a bouquet of lilies I had just purchased in the market. She took out a pair of scissors and cut the top off a plastic water bottle.

"Un vase Americain," she said tartly, and handed it to me.

Each day I would lean my drawing pad against my knee, my right foot propped on the large dormer ledge, the window wide open, and draw the fat iridescent pigeons and the steep blue slate rooftops of Paris. Because I used the one glass in the room for my brushes, Barb poured her red wine into the square white plastic Cinzano ashtray and sipped as she read aloud from A Moveable Feast. I delighted

at Hemingway's hunger and at the big meals and bottles of wine he drank after he wrote.

I decided on the flight over that I was going to paint twelve pictures in the month we were there. A casual six or nine or even eleven would not do. Our first stop was Paris, and in the paper store there I found *une pochette de douze feuilles* (a folder of twelve sheets), suitable for crayon, ink, gouache, charcoal. I planned to fill each page with a picture. I bought gouache cakes in six basic colors. I felt proud to have graduated from kid's watercolor sets.

In each place we visited I painted our hotel room. I began to excel at straightback wooden chairs, painted-wood doors, bureaus with lace doilies on top and an oval mirror attached, chifforobes, pillows flopped onto beds, walls with plaster cracks and uneven baseboards.

In Florence, I painted the Arno River and a bridge; in Zurich, the train station; in Greece, on the island of Naxos, I painted a big ship, and in another picture, I drew our big empty hotel room, looking out on the ocean, and the thin white nylon curtains flapping back and forth across the sill of the open window. Barbara would fall asleep early, exhausted from our day of sightseeing, and I would paint until three or four in the morning. I felt a terrific urgency; I had to fulfill my quota. The only light was from a small lamp near my bed; otherwise, the room was dark and I could feel night out the window. Barbara threw off her covers at seven, demanding, "Let's see it," and I would bounce out of bed with the energy of exhaustion and show her my wonderful new painting.

I think it was the last night on that Greek island that I did the first painting that did not rely on any original detail in front of me. I trusted my imagination completely—the confidence came from the full month of intense picture practice. On that last morning on Naxos, I showed Barbara a painting of a pink plane rising out of the Hudson River with a heart on one wing and PARIS OR BUST printed boldly on the other. Ducks and an octopus were in the water. It was

that last night in the early hours that I felt our whole trip was a victory. We had made it to Europe-how far we had come!

The next day, we flew from Naxos to Athens, our treat to ourselves instead of a twelve-hour ferry ride back to the mainland. I had eleven finished paintings and the outline drawing for the twelfth. I packed that pochette de douze feuilles into my small nylon gray suitcase and dropped it off at the baggage counter. I never saw it again. I remember waiting at the conveyor belt in Athens as the last bag appeared-not mine. I was sick to my stomach, standing emptyhanded in a plaid traveling dress. I pleaded with Olympia Airlines: You can have my toothbrush, the new black dress I bought in Rome, my hairbrush, my jacket, but let me have that packet of twelve papers crinkled with paint and color. I felt an ache, a horrible longing to see those pictures again. I could not believe they were gone.

When I got back to Taos, I used the psychology of a kid who falls off a swing and gets right back on. Shaking, I said to myself, "Nat, you better go get a pen, a piece of paper, and start drawing. Otherwise, you will never do it again." I got my pad and paints and plopped myself in front of a bus and drew it and then added chickens and ducks and I kept going. I added a Mobil Oil sign, sunflowers, vellow hills. I did thirty-five paintings that fall. I did not dare look back or remember.

LESSON SIX

You have fifteen minutes. Go. Keep drawing anything you want until the time is up. Done with your picture after eight minutes? You have seven more to go. Stretch yourself. Keep adding things. Imagined, unimaginable, things right in front of you—your foot, your hand, the cat in the corner. Don't cross out or erase. Just keep going for the full time.

This exercise pushes you beyond where you are when you think you are done. It can break barriers—on the paper and in your mind.

LESSON SEVEN

Go outside. We hang around indoors way too much. Bring a pad and a pencil or pen, and, if you like, a notebook. Let's begin by simply drawing what's across the street from your apartment or house. You could have looked out your window to do it, but it's more lively to have closer contact, the fresh air in your hair and nostrils. Too cold? Think of Alan Furst in Sag Harbor on Long Island who writes his historical spy thrillers in his unheated garage deep into fall. When it hits forty degrees he goes inside. We can match his determination, can't we? You'll get a better angle on the curb, plus you can draw what's down the block if you are outside. Try drawing the same thing in each season. If you live in the country, draw the fence, tractor, sheep. You get the idea.

LESSON EIGHT

Take a slow walk and look around you. Feel your feet in your shoes.
Be happy you have shoes. Keep walking. One step at a time. What would be fun to draw? Keeping that question in mind prods you to pay close attention: the grass sticking out of the cracks in cement, the steps leading to someone's porch. Sometimes I draw nothing on these walks but take note in my mind or notebook: Someday I must draw it. The world will not be complete otherwise.

Sometimes I like to savor lost items—the lost glove that is lying on the street—let the anticipation build in me. But what if later the glove is no longer there? Why not draw it right away? I am always readying myself for future lost objects. Our lives are full of them, waiting to be found. One way is to draw them right now, another is to remember or cogitate on them. They exist, they didn't evaporate. They just aren't in our ken. When we are ready, we can bring them into vision by drawing them.

List in your pad or notebook ten objects you have lost.

Should we dare to go further?
List ten people you have lost, either through death, a break-up, a move, a divorce, a misunderstanding. Did you ever really lose them? If you did, how can you remember them?
What would you draw now?

Luxembourg Gardens, 2006

Cactus, 2004

THE SOURCE OF MY WRITING

IN SEPTEMBER 1986, I DECIDED TO STOP PAINTING. I WAS SITTING ON A WOODEN CRATE, ON THE ROOFTOP OF A PENSIONE ON THE PORTUGUESE COAST. IT WAS MY SECOND VISIT TO Europe. Two black, snarling dogs were chained to a gate on the next roof. The dark immensity of the Mediterranean was in the distance, past the TV antennae and electric wires. I stared up at the night sky and took a deep breath.

I am almost forty, I thought. I want to give everything to writing.

I was resolute. When I returned to the States a month later, I abandoned painting. I resolved to put all my energy into the novel I was working on. At the time, it seemed to express my dedication to writing. It seemed like a good idea. It wasn't. I proceeded to hack my way through that novel for the next three years, and I hated it. The only reason I continued was brute stubbornness and a faith in practice under all circumstances.

Those were dark years. I rarely expressed to anyone how desperate I felt about my work. I couldn't! I had just published a book that launched dentists, quarry and factory workers, psychologists, housewives, Zen masters into their notebooks, filling them madly in

cafés and truck stops all over America, because I had written so clearly and enthusiastically about writing. Meanwhile, I sat at the Garden Restaurant on the Plaza in Taos, New Mexico, wishing I could launch a new career myself—as a truck driver.

When I left painting, I didn't realize that I gave up a deep source of my writing, that place in me where I can let my work flow. When I cut out painting, I cut off that underground stream of mayhem, joy, nonsense, absurdity. Painting was what continually kept those ducts clean and open, because I never took painting seriously. Without painting, sludge gathered at the mouth of the river and eventually clogged any flow. Writing received too much direct, conscious attention. I strangled it. I understand now why couples have two children: so neither one can receive the force of all their love. It is too much. Without painting, writing became a force-fed baby.

I didn't know then that color—the green of cottonwoods at the very tentative beginning of spring, a worn gray lintel over a door, the fading turquoise on my outdoor wooden bench—sustained my life, and that the vision I used for painting actually brought me closer to the written word, that noticing a light spray of brown freckles across a nose carried me into a deep desire to tell a story and to explain relationships. When I painted, I was moved by rain, the light on snow, how haze softened a mountain and tree.

For all the dozen years I had painted—and I began at the same time I started to write and meditate—I never let it have meaning for me. I think I was afraid I couldn't do too many things at once, that I would lose control and get swallowed up. But by not being awake to painting's value in my life, I nearly lost it altogether. It was not unlike cutting off my left arm, thinking it unnecessary: After all, didn't I hold a fork, a tennis racquet, a pen in my right hand? So for four years I hobbled forward, cutting my way through the dense forest with a writing tool in my right hand, not knowing how lonely I was for painting, my lovely enricher and warm sustainer.

For so many years, I did writing practice beginning with "I'm remembering," or "I'm thinking of," or "I'm looking at." Then I would switch my writing to begin with "I'm not remembering," or "I'm not thinking of," or "I'm not looking at," always sensitive to rooting out the underbelly, the dark, the unseen. Painting should have been at the end of those phrases: I'm not looking at painting; I'm not thinking of painting; I'm not remembering painting.

I bought works by artists in and around Santa Fe and Taos until there was no more room on my walls. My friends would comment when they saw my purchases: "Hey, they kinda look like yours."

And I nodded, knowing I bought them because I wanted to be doing them. That promise I made on that rooftop in Portugal carried more power than I had understood.

Then I found out my beloved Zen teacher, Katagiri Roshi, had cancer. For a year, I flew back and forth to Minneapolis. I had little time for much else than teaching and writing-and a constant prayer for his life.

On the night of February 28, 1990, I had this dream: I was standing in Minneapolis with a group of friends. I told them that we each should find a spot on the street and walk back and forth. I crossed the street and found my spot on the corner. I walked back and forth, saying over and over, "It's vibrant." I stopped. Suddenly I flung open my arms. I called out, "No! I'm vibrant!" And with that, everything became alive. A beautiful thin maple with delicate green leaves was on the corner. If I leaned my head in the right direction, a cloud was in the center of the tree. I moved my head several times to see the cloud appear and disappear. I turned and saw a friend farther down the block. She had found her spot and was walking back and forth.

Just then, in early morning, the phone rang. A friend from Minneapolis called. "Nat, Roshi died a few hours ago."

I hung up and lay in bed a long time. No more Katagiri, no more great teacher, I whispered into the pillow over and over. Yes. I thought, the dream is right—all of us in Minneapolis have to find our own spots now.

I also knew the dream was about painting. Only in my painting mind could a cloud live in a tree. When I painted, boundaries dissolved—anything was possible—life could reappear with color. And just then I wanted life to reappear very badly.

I recalled something Katagiri had said: "A promise can be broken, but be careful of making vows. A vow cannot be turned from so easily, no matter how hard we try."

I had made only a promise that night in Portugal. I could reclaim painting—I could do it, this time, for him.

A few months after Roshi's funeral, I began to contact painters with the idea of interviewing them, to see if they too worked in other art forms. When I quit painting, I did it under the assumption that one had to consolidate, not be scattered, not do too many things. Somehow, in these interviews, I sought permission to be all that I was—if I wanted to paint, to just let myself do it.

The first artist I visited was Ginger Mongiello, an abstract painter from Taos. When I arrived at her place, I was surprised to find that half of her studio contained a potter's wheel and shelves of drying clay vessels, cups, bowls, and plates.

"Oh," she said "I use throwing pots to ground myself, to come back to something familiar when my painting feels too unknowable—when I'm not sure what is being formed. I also use pottery as a way to stay in touch with myself—clay holds a physical presence that enables me to go deeper into my painting."

Pottery, she told me, used to be her main art form. She had been startled to discover that a simple design—say, a square with a cross—that she put on a plate years ago now loomed large in a painting.

I felt affirmed; my mind expanded. I was enjoying myself, sitting in her studio, munching on chocolate-covered graham crackers and sipping from a cup of tea.

Then she stunned me: "You know what I'd really like to do is divide my time between music and painting."

"Music?" I gasped, wiping a crumb from my lip. "You play the piano, too?"

"Yes, I play classical piano music, but I wish I could play improvisations. I take improvisation into my painting."

"But if someone asked you what you are, what would you say?" I quizzed.

"A painter," she said clearly.

We went into the other half of her studio. I immediately walked over to two paintings leaning against a wall. They seemed connected to each other in that both had a strong black abstract form in the center and an explosion of colored energy that either reacted to or emanated from that form.

"These are terrific," I exclaimed. "How do you do it?"

She explained that she placed eight to ten sheets of paper on the floor. With a huge calligraphy brush dipped in black sumi ink, she quickly, without thought, flew from paper to paper making dark strokes and slashes. Then she paused a moment, surveyed the papers and more slowly, meditatively, applied a few more brush strokes. She let them dry and then observed what she had done.

Maybe out of ten, she said, she might find one or two forms that interested her. She put the others aside and then worked with those two, responding to the black streaks—sometimes ink drippings—with acrylics, pastels, pencils.

She said that although she explores many approaches and ideas, she comes back to this one technique often. It feels like innate imagery for her, as though it were her own body language.

When I left Ginger's, my mind felt as I imagined hers to be—a series of mirrors, one reflecting another: a Bach fugue manifested in the heart of a painting; a gesture on paper casting back to a clay cup; a blue vase echoing a harmonic scale that vibrated in red pencil.

Without knowing it, I realized I had used painting for years as a metaphor or mirror to break out of something I didn't understand in writing. If I could capture that old tavern in Elk, California, I would understand how to write about aging. If I could grasp how to set down that bus between the houses in Fort Bragg, with the smokestacks in the distance in early evening, I would know something about Mendocino in winter. I'd be closer to season, changing light, and California, a state foreign to me.

As I turned onto the pavement from the dirt road, I remembered that for over a year I had kept on the table next to my bed a postcard of a Dufy painting of the Nice shoreline. I would study it, morning after morning, to see how this painter I loved used gestures of white over a darker blue background to indicate clouds moving out to sea, and palms bending in the same direction as a tilting sailboat in the distance to give a feeling of rising wind. I almost smelled the oncoming rain and I loved the repeated red-tiled roofs. What pleasure I had felt in that painting—it was called *La Baie des Anges* (Bay of the Angels). I'd let the picture sink into my whole body. I didn't worry whether it fed my writing or painting part; it fed all of me.

I recalled a fight I once had with a lover. We left each other angry. The next day I took a long walk, looked up at the aspens, saw how their leaves had changed. *It is October*, I said to myself. I stopped at a local grocery, bought an apple, took a big bite out of it and turned the corner to my street. I hadn't thought of my lover for a moment all afternoon; yet when I got home I went directly to the phone, picked up the receiver and called. "Let's make up. I miss you," I said. I had moved into a new open space.

In this same way, I would call painting back into my life. Roshi was gone. I needed everything that could nurture me.

Striped Chair, 2004

LESSON NINE

Go to a museum or a gallery. Choose one room and walk around to study each painting. Need an incentive? You get to take home one painting in that room. Which one do you want? This revs up the concentration-and interest. It's personal now.

After you've picked your painting, stand in front of it and describe in your notebook what the painting looks like. Give us a picture of it in words, and then explain what is in it that made you choose it.

It's good to stretch your verbal connection to visual art. It expands your ability to see, which will expand your ability to paint. And you get to take that writing home.

Don't stop at writing about a single painting. Practice verbal description of the visual often. Flex those muscles. It's important for visual artists to be able to articulate their process and to use language.

LESSON TEN

Right now, make a list of everything that supports and nurtures your painting life. Don't leave out cookies. your favorite writing chair, Frank Sinatra, or old rock 'n' roll songs. Whatever feeds you-take heed and reach for these when life and inspiration are lagging.

Deux Garçons, Aix-en-Provence, 1992

AT THE HOTEL SPLENDID

IT WAS MY FIRST MORNING IN AIX-EN-PROVENCE, THE TOWN WHERE CÉZANNE WAS BORN AND LIVED MOST OF HIS LIFE, AND WHERE ALL THOSE BOYS OF THAT PERIOD IN FRENCH art—Manet, Renoir, van Gogh—spent some time painting. Picasso was buried at his home several kilometers away. I'd heard there was a special light in Provence. I wanted to see it, but I felt competitive, too. What could outdo my precious New Mexico light? I lay in my bed, six long flights up in a room I fell in love with the moment I saw it: Dark flowered wallpaper, pink carpet, low bed, a plain, small table by a window that pushed open to the tiled rooftops of all of Aix—and very cheap. "Splendid, splendid, indeed," I repeated in my best Brooklyn-French accent as I watched the swallows circle ever higher in the blue sky of southern France. Yes, it is a good sky, I thought. More sentimental, softer, more bourgeois than the stark wild blue of Taos, but good just the same.

I managed to get up in time to have breakfast. It was served in the scrungy first-floor bar, which also served as the lobby and reception desk. I sat at a brown square table with a long thin glass of fresh-squeezed orange juice and a thick white cup of coffee. Opposite me was a new painter friend, Phyllis, whom I had just met at a three-week retreat with Zen master Thich Nhat Hanh at Plum Village, near Bordeaux. It was now early July.

I admired the spoons. I had one in my cup and another in my glass of juice. "The French know how to create spoons," I said. "There's a long thin one for the glass, a small delicate one for the cup."

Phyllis agreed. "They are precise, the French." She paused. "I'm not precise. When I try to talk about my paintings, I can't. I begin with one thing and that one thing has everything, so I can't shut up." She shook her head.

"Phyllis," I said, "you are Southern. Southerners think like that. They have a story for everything." Phyllis looked surprised. I nodded. "One of my closest friends back in New Mexico is from Baton Rouge."

I took a bite of my croissant. "Phyllis, when you write about your paintings, you should begin by simply telling the truth. Say, 'I'm Southern. One thing contains everything. A glass is not a glass; it has a whole world. When I paint a sunflower, there is a whole story."

Phyllis whipped out a pen. "Wait a minute, let me get this down." She grabbed a paper napkin and started to write. Then she paused and looked up. "Natalie, I can't say I'm Southern."

"Why not? You are, aren't you?"

"Yes, but that's the one thing I try to avoid, especially living in New York City. New Yorkers think Southerners are stupid."

"Phyllis, are you going to make believe you're somebody else? You can't be an artist and do that."

Phyllis got up, telling me she was off to the museums. I continued to sit at the small table and turned to look out the window. I ordered a Coca-Cola. I loved the straight-sided, clear glasses they poured it in, right out of those green, old-fashioned bottles. An old woman and a small dog on a leash walked by.

I thought about my painting. I could never just stay with the starkness of a singular slash of paint across the page. My hand would

grab for yellow and then I would want to add green. Pretty soon I would feel purple must have its due, and before long I'd have filled a page. The result often felt busy, too much, a frantic avoidance.

I remember once thinking I'd like to paint a friend's hiking boots. They were a dusty blue, a shade I did not have a precise name for, and next to this blue was a pale gray suede. Now those two colors together woke yearning in me and I wanted to capture them. But I had the urge to add red shoelaces on those boots. Those shoelaces, I thought, exemplified the problem, the crux of all my paintings. I wanted the red, although I knew it distracted me from the simple perfection of gray and blue, but when I painted the red, then I wanted to add a dash of orange, and then, oh lord, how could I forget lime green. Pretty soon I missed pink, and then I'd feel an urgency to brush a patina of turquoise in the background. In my true ascetic heart, I would have been happy with the austerity of blue and gray and a lot of empty space on paper, but always some surge of emotion urged me to cover everything with color and fill in all the spaces. It was like what happened when I spent a lovely afternoon at a lake. I would begin to think how I could have more of that happiness. I could earn more money, buy a cabin and take off three weeks to be there. I'd need at least four new bathing suits; I must be careful of so much sunand the mosquitoes!-I'll need to screen in the front porch. Pretty soon this one lovely afternoon has led to a monster plan to ensure less time at the lake, more time with the upkeep of a vacation home.

With painting, too, the only real simplicity I found seemed to be in the simplicity of the moment, that one moment I leaned over the paper and added maroon to the page, then the next moment when I added black. Simplicity never was in the whole result. Maybe the true wish of my heart was not simplicity but only to manifest myself-if I feared death, let me fill my paintings with its opposite, life.

Now I was really settling into my musing. This was my idea of life in France: contemplating art and death for endless hours in a

Across from the Hotel Splendid, 1999

café, no one rushing me to pay my bill. I asked the waitress for some Gaulois cigarettes.

"Unfiltered," I requested. Didn't Hemingway hang out in cafés, with James Joyce at a nearby table?

I remembered a long time ago seeing a black-and-white photo of the painter John Marin, taken by Paul Strand around 1930, when Marin was staying in Taos. He had on baggy cotton pants, a long cardigan sweater, a scraggly hat; one leg was far forward, leaning toward his easel. In the background was a river. His neck muscles were tense, his face hawklike, he had a cigarette hanging out of his mouth. That one gesture said it for me—though art was intense, there was also a nonchalance in the puff, the smoke, the ease of tobacco.

I ordered unfiltered, because it seemed more raw, closer to the heart of things—well at least, for sure, closer to the lungs. I was no

fool, though. I didn't actually inhale my Gaulois-after all, I was scared of dying, especially of emphysema.

I looked at the big white-faced clock over the bar. It was just eleven, not yet time to meet Phyllis. I lit a second Gaulois and watched the smoke rise as I held it between my index and middle fingers. I looked at the cigarette's paper. White. Now there was a color, I thought, and it was already a given on the page. Often when I painted, I wanted to express my feelings about white, its different shades, how it looked in shadow, bending toward gray, blue, green, how it held up black and how white could move through a person's face. But my paintings rarely had an inch of white in them. White had to do with emptiness. I started with something that elemental, but I never could stay with it.

I asked the waitress for my bill and smudged out my second Gaulois in the ashtray. I went up to my room and collected my notebook for writing and my pad for drawing and walked down the Cours Mirabeau, a wide boulevard lined with sycamores that ended in a large fountain of stone lions spewing water. I sat down at an outdoor café. I ordered a coffee ice cream. I wrote for half an hour. keeping my hand moving steadily. I noted the weather, then a dream I had the night before, then a memory of eating at Howard Johnson's on Hempstead Turnpike. No sign of Phyllis. I opened my pad and drew the convoluted cane chair in front of me. I looked around: She was still not back. I added a little round table with a vase and two flowers. Then I added a bird, a tree, another chair. I gave myself a command: Keep drawing until she returns. I added paving squares on the ground and a water glass on the table. Then lines to indicate bark on the tree. I had to keep going. If she didn't return for a week, I'd still be there, moving my pen-not for writing this time but for shape and form and line-filling the page.

LESSON ELEVEN

I recently bought a small print by a contemporary Japanese painter. How to describe it? Two black oblong forms, one higher than the other, seeming to float down on an offwhite background of delicate texture built by scratch marks in the paper. When anyone visits, I say, "Come and look," and direct us over to the painting. Obviously, I'm excited about it, but it's clear that my visitors are full of consternation, brow furrowed, lower lip hanging out a bit, wordless. They are too polite to say, "Huh?" or "What is it?" But one day an old friend stood over it and I decided to help by saying, "You see, it just is." My friend lit up when I said this, her life broader than she thought. A painting with no cause, no commentary, just a moment. What relief.

Now you try. Get several small sheets of paper and a single marking tool: a pencil, black ink pen, charcoal, even a black felt-tip marker. Sit quietly in front of your paper stack. Still your mind and feel your breath going in and out of your body. Without effort, when you feel you are ready, pick up your pen and make some marks on the first piece of paper. See if the marks can come from your whole body, an expression of you-and not you-an expression of this very instant. Do not hesitate and do not push it too far. Do not doubt yourself. Make the marks and let go.

Return to your breath, your empty mind—let go of what you just did—and wait until you are ready for the next piece of paper. Accept the next group of marks as they come; in a sense, receive them. Continue for at least five rounds. When you're done, put the papers away and give yourself at least a day before you look at them. What do you think?

Do this exercise at least once a month. Over time you may have made some real haiku drawings.

More important, it is practice in learning to accept your mind as it is in the moment, and to develop a deeper relationship with simple line.

LESSON TWELVE

Agnes Martin is a famous painter who settled late in her life in Taos, New Mexico. At ninety she gave seven of her large grid paintings to the Harwood Museum in Taos and the museum built a special room to house them. Recently I heard that local children's groups are learning about Martin, and right in the room where her works hang, they lean over paper and try to imitate her. What fun, I thought.

It took this artist twenty years to discover what she wanted to paint—straight lines across the page. Some close together, some further apart. Her grid paintings in the Harwood are titled Lovely Life, Friendship, Perfect Day, Love, Ordinary Happiness, Innocence, and Playing. The bottom

Three Blue Forms, 2013

colors in each painting are washed over with white to create a vibration emanating from the canvas, fulfilling the ebullient titles.

I sent a group of adult writing students to the Harwood to see these paintings. A young woman from Minnesota came back early, "They weren't there. They took them down."

"You're kidding. They never take them down. Are you sure?"

"Yup. All that was hanging was white canvases."

My eyes opened wide. "Those, my dear, were the Agnes Martin paintings." Her face reddened from the chin up. "Look harder next time." I smiled broadly.

Maybe you don't have Agnes Martin paintings right in front of you, maybe you've never seen her work. Plan to look her up sometime, but in the meantime, simply draw lines across a blank page. Use a ruler if you like (she did). Draw lines close together, far part. How does it feel? How does it look? She said, "If you wake up in the morning happy without a reason-that's what I paint." Emotions unhinged from circumstance-a taste of the abstract in human life.

Persimmons II, 1993

AT CÉZANNE'S STUDIO

"WHERE HE PAINTED!" PHYLLIS WAS IN AWE. SHE SAT IN A CHAIR IN THE LARGE HIGH-CEILINGED, STONE-WALLED ROOM WITH TWO HUGE WINDOWS ON ONE SIDE AND A WALL OF GLASS ON the other. Dried apples and old onions that had originally been used to show tourists an example of a Cézanne still life were now set out on the windowsill for the birds. There was a book for sale of the specific places he painted in the area: a picture of the painting he did there, directions to that place, and the time of day that matched the light when he had painted. The book was in French, which Phyllis could barely read. She bought it anyway.

An original watercolor of hydrangeas hung on the right-hand wall. It was powder blue, gray, and white and had a translucent, luminous quality. The petals were almost tangible, as though I could touch them, but I also felt if I did they would crumble into dust, like dried insect wings.

I watched Phyllis's enthusiasm in the studio. Two days before we had driven out to Mont Sainte-Victoire, which Cézanne had painted over and over. Phyllis kept exclaiming, "There are his trees, those odd angles, the way they grow out of the sides of the hills," and she couldn't get over the fact that the real mountain looked purple, the way he had painted it on canvas.

I had bought some apples for the day trip, and when I held them up, Phyllis said, "Yes, those are his apples. The ones he painted. They have weight, gravity, like no other apples. Leave it to the French."

Yes, the apples were beautiful, big, whole, very dark red and almost navy in shadow. "Well, maybe he painted better apples than anyone else, because he had better models," I said.

"No," Phyllis said. "That's part of an artist's job, to choose what to paint. He recognized those apples. How many people just eat them?"

I watched Phyllis in the studio, digesting Cézanne. This painter informed her life. Not only his work, but how, where he lived. I looked around. I thought, It's all interesting; I'm loving our visits to the painters, but I see that their lives don't move me inside out the way a writer's life does. It was different when I visited Prague, where Kafka lived all his life. Every step I took, I felt like Kafka: his mind, his eyes seeing the stone grave sites in the Jewish cemetery, him moving down the narrow streets. I went to the Kafka museum. Any bit of information about him I ate hungrily. He was engaged twice to the same woman and both times he could not go through with it. He said, "Writing is my life. I cannot get rid of it, but human emotions will eventually pass." He was afraid love would interfere with his work. He died in his early forties. I was in my forties when I visited his city. I wondered if he had lived a little longer if he would have changed. I thought art was everything through my thirties. Then I got lonely-I needed more than writing. But knowing I was in the city Kafka lived in ignited that writer part of me.

I wondered if it was possible for a stranger, a visitor, a tourist, to feel the land of a foreign place well enough to capture it in paint. I thought of Matisse and the paintings he did in Morocco. He soaked up the light there and was able to put it on canvas. Could I paint that cherry tree we saw near the town of Bonnieux, with the long stone wall, so that you knew I was in France and not in the orchards of California?

I thought of Georgia O'Keeffe, who was brought up in Wisconsin and educated on the East Coast, but who then painted New Mexico as no one had ever done before. There was nothing like the eyes of a foreigner who finally found her heart's home. No one else could paint with that kind of hunger and love.

Taos came to me then. Even if I'd been born there, it seemed I would always be a foreigner. One generation would not be enough to say I was a native. Even if my grandfather had come straight from Ellis Island and managed to plant corn in the arid, crumbling earth, I would still be a misfit in comparison to the fifteen-hundred-yearold pueblo at the foot of Taos Mountain. I'd be alien except for my long enduring love of the place, a passion that seemed to reach back before time. And having that, what was it of Taos I'd like to capture in a painting? It came to me suddenly-the stillness. More than anything, its stillness stunned me the most. I remember thinking, yes, even now Taos has it, but until that moment in Cézanne's studio, I didn't have words for what it was. There were afternoons in summer when nothing moved, not a tree, a leaf, no stone, animal, cloud. Everything was in place as if for all eternity. Now lay like a blanket over the land. Life and death, those two dichotomies, in stillness did not exist. How would I paint that? Georgia O'Keeffe did it with bones. My painting would somehow have to communicate breath. What I meant by that and how to do it, I didn't know.

I ESSON THIRTEEN

In 1888, van Gogh painted his tiredlooking shoes on a background of tile floor. The shoes are close together; the left heel touching the right; the left shoe a bit more forward; the gold colored laces looking raggedy—the pair of soles are worn, bushed by the miles they had to walk, the poverty, the pain they had to endure. More than a still life, they are a portrait, an autobiography of the artist near the end. A whole world in a pair of shoes. He died in 1890.

In 1963, nowhere near the end of his life, Wayne Thiebaud painted Black Shoes on an off-white surface with shadows under the tips and sides. These shoes are not touching but the heels are close, toes out. The inside back of each shoe seems to have an almost lit tan leather and the heels are not run down. Shiny dress shoes. No portrait of poverty, but they feel melancholic, brooding. All dressed up with nowhere to go.

So much can be conveyed through an inanimate object, especially if that object is personal. Go ahead. Pick a pair of your boots, sandals, running shoes, slippers. Notice how and where you place them—on a rug, a wood floor, a couch. Do a portrait of them. Choose your medium.

Now try a portrait of your eyeglasses, watch, hat, gloves, pajamas.

LESSON FOURTEEN

Pick inanimate objects that are not so personally close and do a classic still life. Sure, you like strawberries or peaches, but you will go through many in your life. Each individual strawberry or peach is not personal. Take some vegetables and fruit from the refrigerator or the farmer's market and arrange them in a bowl, lay them on a table. Don't get too fussy about the arrangement.

Draw or paint them.

Try a vase of flowers.

In a fancy hotel, I once drew the sink and the faucet and the cold and hot knobs—that was a very still life.

Pie and Coffee, 2006

My Fair Lady, 1984

AT THE MUSÉE MATISSE

I WAS ALONE THE DAY I DROVE THE RENTED CAR FROM AIX TO SEE THE MUSÉE MATISSE IN NICE. I WAS EXCITED. MATISSE WAS ONE OF MY FAVORITES. THEN I WONDERED, HOW DO I KNOW Matisse? When did he become a favorite? I knew there had to have been a time, an exact day that it happened. I was young—maybe I'd found a book on my aunt Priscilla's coffee table. I remembered looking from painting to painting, slowly: woman lying on couch, window opened onto blue sea, table in front of window. His paintings were friendly. I decided I liked this man; he was a good man. I felt connected to the person behind the canvas.

I passed a line of tall thin sycamores. I noticed I was driving way above the speed limit. I slowed down and continued my musing: Well, at least, I thought I'd become acquainted with Matisse, the man, by viewing his paintings—but maybe I was wrong, maybe he wasn't a good man. I didn't know, but I felt good seeing his work and so I felt gratitude and warmth toward him. And his canvases seemed to have such "good" subjects: food on a plate, people having a meal outside, the interior of a home, cups and vases and flowers, a woman playing the piano and a young boy behind her reading a

book—what could be better than reading a book!—another painting of a woman at the piano and two boys playing checkers, lots of floral wallpaper, textured rugs, lovely curtains hanging at windows. And a lot of the women he painted seemed dreamy and content, wearing hats with flowers, garbed in soft-looking, comfortable clothing and sitting in upholstered chairs.

Of course, what I was viewing on his canvases was the painter's mind when he was creating, probably his most transcendent moments, when all objects and people were radiant for him. I didn't know his daily life, his disposition when he awoke in the morning, or how he treated his wife. He looked pretty good, if the man's paintings spoke for his life, but that wasn't necessarily so. I've known writers whose books sent me spinning for months, because those books were so alive, full, joyous. Then I met those writers in person and discovered miserable, crazy, troublesome human beings. But, I think, we all love to project our highest hopes on someone whose work we love, because their work has made us happy.

When I went to high school a writer's life was never discussed. As I grew up and became a writer myself, I wanted to know about the artist behind the work, how the two coincided and fed or did not feed each other. Maybe it wasn't fair to expect a person to live up to his or her work, but I also knew I wouldn't read a novel by Adolf Hitler, no matter how good the critics said it was. Still, I loved Hemingway, even though his women characters were often two-dimensional, and I enjoyed the wild, dark energy of Celine's writing, though he was a crazed fascist—with Celine I rationalized that he never killed anyone.

I remember the moment clearly when for me Picasso fell from his pedestal as the genius creator of the twentieth century. In my child-hood his intense dark eyes blazed from covers of *Time* and *Life*—he was considered the ultimate artist. No one else came close.

"He could paint beautifully, even at twelve," my eighth-grade

teacher told us as she pinned a blue picture of a man playing a guitar on the front bulletin board.

"A whole movement—Cubism!—was because of him!" Aunt Priscilla exclaimed. "He's a giant, a wizard." She threw out her arms.

I had just turned forty and was in Paris at a drawing retrospective from the last ten years of the great master's life. True to form, Picasso was prolific, even near the end. The show at the Pompidou center was extensive. Room after room of sexual positions, men and women naked, half-human, half-animal, all in black and white. Nothing else, no other subject. Then finally on one wall a single small colored painting of two trees. What a relief! I stood in front of it and felt as though a cool breeze just blew across my eyes. Could this be true? All this the culmination of a great artist's life? Only this theme? No other subject?

A few months later I read a shocking book, *Picasso: Creator and Destroyer*. I learned that his second wife—and his grandson—committed suicide; Marie-Thérèse, his mistress of many years, killed herself; Dora Maar, his lover during the time he painted Guernica, had several nervous breakdowns. When he heard that Françoise Gilot, another one of his lovers and the only one to survive intact, had married, he said, "I'd rather see a woman die, any day, than see her happy with someone else."

Craziness, neuroses I could accept. Cruelty I could not. I decided I didn't care about Picasso, and when I saw his work after that, even paintings I'd grown up with, like *Family of Saltimbanques*, *Still Life with Violin and Fruit*, and *Guernica*, I no longer felt awe. I kept my distance as if I were visiting an ex-lover who'd once broken my heart.

So far Matisse hadn't disappointed me. And now I was in the Matisse museum, which had only a few paintings or drawings in each room of the old building it was housed in. The walls of each room were painted a different color, which imparted a cozy, intimate feeling. On one wall there was a painting of a chair. The whole

chair could not fit in the picture. You felt the rest of the chair hang outside the frame. Just yesterday I had drawn a chair at Les Deux Garçons, and I found it hard to fit the whole chair on the page. I never thought of simply letting it overlap in the viewer's mind. Matisse fit in part of his chair and I knew his whole chair.

It was like that in writing, too. Tell a moment of someone's life, put it down in words really well, and you have a whole world.

I remembered the garage door—one I'd seen years earlier, the same summer as the Picasso retrospective. I had gone to southern France, near Bordeaux, to my first month-long meditation retreat with Thich Nhat Hanh. I'd snuck out one afternoon and walked four miles through beautiful patchwork fields of barley, wheat, and grapes. I went to a small town, Sigoulet, to buy a baguette—I wanted one, as though it were an emergency.

After I left the bakery with my prize, I walked down a narrow street lined with stone buildings. I peered into a grocery; rows of chocolate, cans of sardines, wooden bowls stacked on the shelves. A gray cat licked at a saucer of milk in front of the barber's. I passed a small park with three benches. I turned a corner—suddenly facing me was a worn-out wooden garage door with chipped turquoise paint. I could see the orange and white of past coats underneath. The door was set in a yellow stucco wall. This I could paint! I thought as I stood there. Then I turned abruptly, crossed the street, ripped off the end of my bread and bit into the crust. I didn't paint the door. I had a pad with me, but I thought the paper was too small. The door felt too big. And besides I had four miles to walk back to Plum Village, where everyone else was doing sitting meditation.

That mistake haunted me for a long time. The turquoise door had a life of its own and that life wanted me. When I returned to Sigoulet two years later, the whole garage had been remodeled. I failed that door, that moment in history. Something wanted to be painted, and I did not heed it.

Back Alley, Minneapolis, 2002

When I got back from France, I looked all over northern New Mexico for that garage door. It wasn't that French air, eight hours ahead on another continent. It wasn't that June, with my forty years in my arms. I tried to paint several other garage doors to make up for it. They were good paintings, but somewhere inside me it didn't matter. I wanted that one door then, and that door wanted me. That missed opportunity was good, I guess. I grew to know garage doors through it. It made me hungry for them.

I could have used the paper I had then and done the garage door the way Matisse did the chair, I lamented as I stood in the Matisse museum. Of course, I'd squished whole pink Cadillacs into pictures, but this was not about squishing the garage door in. This was about letting it live bigger than the paper.

LESSON FIFTEEN

Joan Sutherland lives across the street from me. Every time I visit her I am also visiting her grandmother's faded blue velvet couch with the fancy wood legs and wood trim. That sofa has character and weariness and welcome-ness, "Come, my darling, sit with me for a bit, relax, let go of your ambition, drive, worry. No place to go but here."

One day I sat in front of it and drew half of it. I started big and the whole thing didn't fit on the page, but I knew in that half I had it. Joan wandered back in the room, "That's it. That's the couch." That half of the couch filled the whole paper.

Now what? I wanted to paint it. I was presented with a close up of the arm, the cushion, the back, and the emptiness of the wall, I knew I wasn't going to stick in plaid upholstery or a painting hanging above. I wanted to communicate the electric vastness I felt in front of the couch. The emptiness wasn't a void-it was alive with at least a hundred years of people sitting, leaning, drinking, reading on it, and it was witness to all kinds of love talk, gossip, political intrigue. I didn't need to add one extra object. It was full already. So I painted it by layering one color after another. I began with blue, because it was the color of the couch, but quickly moved on to yellow, orange, brown. The lavering made it vibrate-it was a field of color.

I called Joan and asked her what tone her grandmother's wall was, if she could remember. Then I painted just the opposite.

Now you do it. Find a single inanimate object you feel has a kindred spirit. You might not find one immediately. Relax and pay attention as you move through your day.

Once you have found it, take a large sheet of paper and draw it. Don't worry if you can't fit it all on the page. Let the parts speak for the whole.

Now use color. Pastels, water-color, colored pencils. Layer the color, one on top of the other. Apply each layer lightly so the color below can breathe through and have life. Don't squash the previous color. It's the combinations that make the single object vibrant.

Then paint the background, but keep it simple.

This kind of painting takes practice in order to not crush or overwhelm the colors below. Don't like the result? What you don't like in this painting will enrich your next one.

Portrait of Joan's Couch, 2012

Ohio Buckeye in Gramercy Park, NY, 2002

MATISSE IN NEW YORK

FOUR DAYS AFTER MY VISIT TO THE MUSÉE MATISSE IN NICE, A TRAINED GUARD DOG TOOK A HUGE CHUNK OUT OF MY RIGHT CALF. THE DOG HAD BEEN HIDING WHEN I SAUNTERED UP TO a private house, thinking it was a café. I was in Saint-Rémy, near the monastery where van Gogh committed himself for a year. The nuns called an ambulance and I was rushed to Avignon, yelling in the back, "Depechez-vous," as the driver lingered at the stop sign to light another cigarette.

The twenty-seven stitches the doctor gave me weren't good enough—I had to fly home the next day. Back in the States, I was told to lie flat for two weeks, hoping the sewn-back flap would survive. It didn't. It had to be cut out. Then I hoped the deep gash would close on its own.

After a month, the doctor in Santa Fe suggested surgery.

"No!" I yelled. "Give me more time."

I called a physician friend in Minneapolis and we plotted my cure. I would eat lots of red meat for my blood cells, take many vitamins and stop putting on the ointment that prevented infection. It kept my wound bacteria-free but also retarded my healing. Eliminating the salve was scary—what if my leg blew up?—but I was determined not to go under the knife. I would try anything.

In the middle of October, three and a half months after I was bitten, the Santa Fe doctor told me in amazement I wouldn't need surgery. He didn't say, "You might not need surgery." It was clear and declarative: "You won't need surgery." It was the most beautiful sentence I had ever heard.

I decided to celebrate by going to New York City to see the Matisse retrospective at the Museum of Modern Art. After all, I had legs now—two of them—I could dance, if I liked, through those two full floors of paintings.

As I strolled to the museum from my hotel, I was uplifted by the simple act of walking. I passed the Carnegie Deli on Seventh Avenue. *Broadway Danny Rose*, the movie by Woody Allen, was filmed there. I stopped to peek in and ended up sitting at a long table ordering cheese blintzes—"homemade," the menu said. As I waited for my order, munching a pickle from the bucket before me on the table, I watched waitresses whiz by, balancing pastrami piled so high that the rye bread on top of the sandwich teetered precariously. *My father would love this place*, I thought.

The blintzes were delicious. Three big ones, and I finished them all. Thus fortified, I went to see four hundred paintings by the Frenchman who had stated that his "aim was to create a calm and luxurious art that would soothe and please, and offer relief from everyday life." I needed to be fortified: Even though I had a reservation, the line to get in wrapped around the block; the entrance was jammed when I finally came near; and sorrowful-eyed people by the door begged for my ticket—"I hitched here all the way from Cheyenne, I gotta see him." I looked stiffly ahead, reminded myself that I had journeyed from Taos, and waited on my glorious legs to see those calm and luxurious paintings.

Matisse's genesis as an artist was posted at the beginning of the exhibit: A law clerk, he began painting at the age of twenty while he was convalescing from appendicitis at his parents' home. Little more

than a year later, in 1890, he abandoned law altogether and went to Paris to study art. Painting, he said, opened for him "a kind of Paradise" set apart from ordinary life.

He was headed in one direction and then zap! a case of appendicitis became a gift-he let himself be seduced by pleasure. It was his guide and he followed it. Pain is not the only way we can learn, I decided right there. I'd had enough of it with my leg. I could open to "paradise"-I was ready for that now.

Matisse chose ordinary scenes and objects to depict his Eden. Perhaps he was saying that heaven was only a paintbrush away. Merely lift it up, apply color to canvas, and everything becomes transformed. In a sense this was how I experienced his work, not as an escape but as a new entry into life.

I moved through Matisse's Fauve period. He and Andre Derain went to the small Mediterranean seaport of Collioure, near Spain, and inspired by the works of van Gogh and Gauguin and the lively colors of the town, they painted intense colors directly on white canvas with no preparatory sketches. In other words, Matisse used pure color to "build" his painting. He let the painting be constructed by means of color alone.

I looked closely at Brook with Aloes. I loved how the green of the single tree on the horizon lay next to the blue of the sky with no outline between them. The aloe plants on the hillside, the stream, the rocks in the stream, all shimmered, the colors intensified by the abrupt juxtaposition.

When these paintings were shown back in Paris, they were considered so crude, so rough-splashes of bright color direct on canvas! Mon Dieu!-that Matisse and Derain became known as les fauves, "the wild beasts." I liked that raw, open quality.

A woman in yellow pants parked her stroller in front of Dance, a big oil of five nude women in a circle on green grass against a blue sky. She squatted down and leaned her cheek close to her baby girl's face, cooed a bit and then was silent and intent. Together, mother and child peered up at the painting.

"She's really looking," I said to the mother when she stood up. She nodded. "It's the colors."

9,0

I FELT SATURATED. There was so much color, so much light—so many people—I just collapsed on a bench and eyed the guard standing by the doorway. Do you think he'd mind if I lay down? I thought I'd try. Within a second, he swooped down on me and actually kicked my hurt leg, which was hanging over the end of the bench. I jerked up.

"No sleeping or lying down here."

Ever since I was a kid, museums have enveloped me in a profound sleepiness, no matter how engaged I am in the paintings on the wall. My eyelids get heavy; my limbs droop. I suddenly feel a deep connection to the earth and want to lie down on it. No earth in sight? The floor or a bench will do. During my hippie rebellious period, I used to think my sleepiness was a political statement: Museums were dead institutions, totally removed from life. Now I think my exhaustion lies ever-present in my bones; those rooms full of paintings simply call that weariness out of me, like the outbreak of acne I always experience at the beach. The sun performs its purification on my skin. The museum does the same for my energy; it leaches out everything in me that isn't alive.

I got up from the bench. More rooms of paintings, and I am still barely on the first floor, barely through World War I. How do I digest all this? I asked myself.

You don't, I answered.

I decided to relax and be there solely for pleasure. And how do I derive the most pleasure? Well, one good way would be to become friends with three or four paintings: Oh, yes, I know that one! Then the atmosphere won't feel so foreign, I told myself.

Now when I saw a painting I was drawn to, I just stood before it. After all, this painting must have taken Matisse a long time to paint, I thought, not to mention a whole lifetime of practice behind him, so the least I could do was stand before it for three full minutes. It was surprising to me how long a minute was, much less three. The crowds intensified the time: They were impatient and swept by me.

So now imagine three minutes of full attention, sucking in with my eyes the color, the form, the movement of a Matisse painting! How did he do that anyway? I asked myself, standing in front of *Still Life with Oysters*. Why did he paint that tablecloth red and why are there only oysters, a knife, a pitcher, and a mat? And what is it about this painting that I liked?

"It's purdy," I told myself.

Yes, anything else?

I liked the two red stripes on the napkin and the vague purple in the oyster plate and the canary yellow of the lemons next to the off-white oysters and the dark blue, no, more royal blue, place mat that the plate of oysters was resting on.

Yes, look further, name more, see more.

I liked the yellow handle on the knife and how it was all alone, by itself, on the mat, the green lettuce along the rim of the plate and how the rectangle of the mat went diagonally across the rectangle of the canvas. I didn't like the pitcher. The purple color wasn't rich enough. The pitcher looked suspended over the mat, as though it wasn't really part of the scene, as though Matisse forgot to give it his attention—maybe his toast was ready and someone called him into the kitchen to have lunch and he left abruptly and never came back to finish it. I did like the light orange mat under the blue mat and also the bit of black pencil or charcoal lines I saw that Matisse drew before he painted his picture.

Did I sound a little simple? Good. The dumber I got, the better. I didn't want fancy art theories. I wanted a direct connection with the

Looking Down from 3rd Floor at MoMA, 1999

Across the Hudson, 2006

painting before me. Me, standing there on my two wonderful feet, the breath going in and out at my nose, looking directly with my two brown eyes at the colored forms of Matisse. Nothing between us. My mind meeting his mind. Naming everything I saw in the painting helped me bring my two worlds together: the visual and the verbal. Naming helped me to look more carefully, to become friends with the painting. It was no longer something too "cultural," too foreign—too French. It had joined my world, my stream of language.

Then I fell in love with *Small Odalisque in a Purple Robe*. A darkhaired woman lounged across a sofa in a purple and pale green striped, long, open chemise. She seemed to have a light spray of yellow flowers in her hair and was holding a long string of black pearls partially wrapped around her wrist the way I've seen Tibetan monks carry prayer beads. She was barefoot and her feet and calves were much browner than her hands, neck and face. But it wasn't really the woman or her dress at all—it was the sofa I loved. The sofa was gray. That was the moment I realized that of all the colors in the world, gray was my favorite. Those gray skies of Minnesota had taught me well. Gray clouds, gray men's suits, gray dusk shadows. Gray was the netherworld, neither black nor white, the gray area, the undefined.

I went upstairs to the next floor. Here were Matisse's paintings from Nice. I liked them especially, because I'd been in Nice the summer before, so I felt close to them. There was *The Rocaille Armchair*, the chair that couldn't fit into the picture. I was pleased to see it again. I knew its true home, in the Musée Matisse.

I read on a placard on the wall that Matisse felt "an eternal conflict between drawing and color." I thought of how I yearned off and on to learn how to paint without lines, but then I'd give up on the idea. It always seemed too complicated, but I was amazed that Matisse felt it, too. In his late years, he resolved the conflict by doing cutouts. Instead of drawing an outline and filling it with color, he could draw directly in color. He drew with his scissors by cutting

shapes from paper he had prepainted. Then the contour of a shape and its internal area were formed simultaneously.

I headed for the cutouts, which were in the last rooms of the show. I was excited. In his late years-he died at eighty-four-he merged line and color. What a victory! I stepped into the first room of cutouts. The four walls of that room held one huge image with many figures and shapes, The Swimming Pool, which Matisse had made to decorate his dining room in Nice. Increasingly sick, often working from his bed, he wanted to have swimmers on his walls because he could no longer go swimming himself. As I stepped into the room, I felt as though I had hit water, something viscous, that slowed me down. I watched the surprised look on people's faces as they entered-they experienced it, too. Everyone felt the enchantment. I literally couldn't move fast. Linear time and space had dissolved. Bathers in blue and white shapes frolicked against a tan sand-beach background. It was as though suddenly we were transformed from "viewing" room after room of paintings to actually being in the painting with the bathers, not only because they surrounded us, but because there was no longer a distinction between those boundaries of line and color. The figures seemed to take off, unfettered, floating in an ocean of delight, as though the spirit had finally been freed of any physical restriction. Line tends to create seclusion, a feeling of separateness. With no lines, we merged with the scene. What we saw, we now were.

I was immersed in the beach. I could feel the old memory of sunlight on waves, ocean current, and the boundless force of water as I felt it as a young child at Jones Beach. And that feeling of awe continued through all the rooms of cutouts. In the resolution of his conflict, Matisse had burst into some joyous unity.

I felt exultant, then for a moment fear like lightning flashed through me—the dog bite—we are mortal, blood and bones. Then I relaxed—old age seemed splendid, if this art was the result. Those

Central Park, New York City, 1990

final cutouts had the courage of transcendence. They felt almost bigger than death.

It was dark out when I left the museum. As I walked down the street, I looked at everything differently. The street light, the tree shadow, the blinking neon sign, the yellow cab that whizzed by, the pretzel cart on the corner, my hand—all colored forms. Everything a painting. Everything alive with its own contour. No longer objects but stops of the imagination. I walked across Fifth Avenue in a concert of shade, shape, and a silent inward singing.

LESSON SIXTEEN

I have a big dark gash at the back of my right calf from that dog bite so many years ago in France. It doesn't hurt, but I can't forget. People ask me about it in summer when my calves are exposed, or I can tell they are looking at it oddly. We all carry scars. Inward and outward. Physical and emotional. Make a list of the ones you have.

Now take objects in your ordinary life—a blender, a pair of scissors, a knife, a spoon, a book of matches, nails, toothpaste—things that don't necessarily have a connection with each other.

Arrange them in a still life. Yes, this is not a classic still life. You might arrange a sprinkler, rubber boot, leather satchel, roller skate, and Yankee mug on a tablecloth. Now paint it, keeping in mind your list of scars, the wounds, bumps, injuries you've collected over your lifetime. This anchors your still life and can give it an emotional quality. A sense of the blows life carries can be transmitted in this odd, jarring combination of objects.

Plus, a still life of these objects breaks the old concept of what still life subjects should be.

LESSON SEVENTEEN

Julia Cameron in her book The Artist's Way has a wonderful assignment: Go on an artist's date. Let's borrow the idea from her. Look at your calendar and in the next month "X" out an afternoon-or morning. It's all for you. On your date, include a stop for coffee or tea, a visit to a museum or gallery, and some time for walking leisurely. Bring a sketchbook or notebook. Maybe where you live has no art galleries or museums. Choose a hardware store, an auto supply store, a wedding dress store. a shoe store-a place you don't normally go. Walk around in it slowly and look, really look-as though it were a museum-at the objects on display. One rule: Don't purchase anythingwell, except for your coffee or tea. This is not a shopping spree.

Feel how it is to be on your own, giving time to yourself to wander. Even if it's two hours a week, conferring time and space like this is an important exercise.

You only have ten minutes a day? You can do a sketch in ten minutes. That's 3,650 minutes in a year. Good practice. Also in that short amount of time, there is no opening or space for judging or consternation. You do what you do. You get on with it.

Summer Tree, 2012

WRITER MEETS PAINTER

THE SUMMER I WROTE THE FINAL DRAFT OF MY NOVEL BANANA ROSE, I WENT TO THE HARWOOD LIBRARY IN TAOS NEARLY EVERY DAY. I SAT IN THE JOSEPH A. IMHOF MEMORIAL ROOM, vigas high above my head, old, out-of-print books on the Southwest shelved around me, a thick wood table before me, comfortable in an old rustic leather chair, leaning over my notebook, one of the locals at the next table paging through *The New Mexican*, the librarians never whispering but speaking loudly to someone who was mishandling a book, the sound of the chain saw right out the huge window opposite me, cutting down a gorgeous poplar I could see against the blue sky, because the Harwood was afraid that in a storm it would collapse on the roof. Some days I'd sit still for almost seven hours. I was deep into the mind and world of someone who did not actually exist in the flesh—Nell Schwartz, my main character.

But it is the time afterward that I remember most, when I left the Harwood, my noisy mind crushed down by so much concentration that, finally quiet enough, I could behold for their own sake the turquoise sills against the mud walls of slanting houses down on Ledoux Street. I'd walk with my notebooks slung in a cloth grocery sack over my right shoulder and feel my feet on the crooked pavement as I crossed the plaza to a side street that took me down to the post office, where I parked my car. That side street was heaven, though there was not much unusual there—yes, in the distance was the majesty of Taos Mountain, and over my head huge spruce trees shaded the street—but because of my state of mind, everything became radiant. I was washed clean. Whatever I had in me, good or bad, I'd given to Nell Schwartz that day, and so I walked with less of my personality and more of my true self. And I developed the habit each afternoon of stopping at Barbara Zaring's studio, which was on my way on that tree-lined street. I'd climb through a section of high fence that had collapsed, and it seemed no one made any effort to repair, and cross her backyard to a freestanding adobe building. I'd pass the big box elder shading her west side and go through her front door edged by bachelor's buttons and flax.

She was almost always there, sitting in a blue chair at the back of the room. The oils still wet on several canvases, she'd be leaning over, reading a book. I'd plop myself on her couch, blurt out everything I felt about writing that day, how far I'd pushed myself, how far the book still had to go, and then I'd look around the room. This studio was big and full of light. She had spotlights she flicked on for me to see her paintings better. She worked on more than one at a time, moving in on a canvas until it would give no more that day, and then switching to another painting.

Her pictures were almost all landscapes of New Mexico, and I could spot the places.

"Oh, there's Valdez," I'd say. "You got the smoky quality of those spring cottonwoods and El Salto's darkness emerging from cold."

She and her friend Alyce Frank would go out in the morning—they'd been doing this together for twenty years—and set up easels by the gorge or the Hondo River or over by Pilar, and then they'd take the work home and finish it in their studios. Once home, the work

became more of an interior landscape; Barbara could move far from the colors and shapes she had seen that day. But it seemed to me the farther out she went, the closer she came to capturing the place.

Just like my novel, I thought. It seemed that the more I exaggerated a situation or fictionalized some old memory, the closer I came to the truth of the experience.

I remember being in California with a friend who had never seen Taos. She wanted to know what it looked like. I had a photo of the Rio Grande gorge. I took it out to show her. New Mexico suddenly looked terribly dull—dry, treeless, bleached out by too strong a sunlight—while my friend and I stood under redwoods near fields of abundant lettuce in reds, purples and greens, growing out of rich dark soil. I snatched the photo away from her and lifted an old Southwest Art magazine out of my pack. I flipped it open to Barbara's Fall in the Canyon.

"Here," I said, "this is how it really looks."

There was an extraordinary yellow light in that painting. That glow was the autumn cottonwoods and the river was a crooked gash of almost white down the middle. Rivers in October look like that, I said. The mountains in the back were dark, almost navy blue; some to the left had orange gouges in them and there were black volcanic rocks on the right and slashes of color. Someone not knowing that canyon might not know the color was also rock, but it wouldn't matter. In that painting was the huge heart of northern New Mexico—full of light, full of darkness. Anyone who has seen the Rio Grande gorge, that canyon, knows that it is real—and also too beautiful to be real. Only with one foot on earth and the other in a dream could a painter capture it.

As I sat in Barbara's studio those days after writing, her paintings seemed to reflect how big I felt, having stepped out of the physical boundaries of my body to move through the minds and hearts of other people in my fiction. I didn't need Barbara's paintings to be an

exact replica of a place. Barbara's paintings seemed to echo instead the whole true world of the land I loved: its vastness, its aching joy and wild celebratory wailing. Someone once said of New Mexico that it's empty, like the mind of God. Empty—and bursting with color.

I realize now that her paintings were the only thing that matched the wild open field I felt inside. They comforted me, because sometimes after writing I felt as though my face had been torn off. I had no facade to rely on for protection. I've learned to live with this over the years, learned to stay away from social interaction right after I'm done writing, to take long walks and breathe in the security of trees and buildings warmed in the sun. Transitions have always been hard for writers—how do you come back down to earth, down to selecting cheese and cans of soup at the grocery after you've been out flying with angels and demons, been to other countries or seen your own completely anew—but here were these Zaring paintings. She'd thrown out on canvas the huge empty singing cavity of my body after I had finished writing. This was new, to view Barbara Zaring's paintings as a way of landing and as an acknowledgment of where I was. I began to need them after I wrote, as a source of joy and connection.

I said that Barbara would be reading at the end of her day. She would also be reading in the middle and at the beginning. She'd work for a while, then bury her face in a book, paint, go back to the blue chair in the back of her studio and read. She'd do this back and forth like a symphony. Paint: the horn instruments. Read: the strings. Paint, read Joseph Conrad. Paint, dip into Dostoevski's mind, paint, be juiced by Virginia Woolf.

One day I asked her point-blank, "Do you know why you read as you paint? It's woven into your work process."

She shrugged her shoulders. "The only thing I know is I can't tolerate poor writing. It irks me—and I'm not usually a snob." She laughed. "Hey, I like junk like everyone else, but," she shook her head, "I can't stand poor writing."

Two years earlier, when I'd been interviewing painters, I found that the women painters I talked to had little analysis of their work. They didn't seem to have thought about their process very much. They were happy to get their work done. Of course, there is the old idea that visual artists or musicians aren't good with words. Georgia O'Keeffe, when asked what her flower paintings were about, said something like, "They were pretty. I painted what I saw." That's very Zen of her, but it leaves us and history out in the cold.

The women I interviewed weren't simple or unintelligent. They were pragmatic, and I was a poor interviewer who could not extract a lot. But I was no better an interviewer when I talked with male artists, and yet they were able to pontificate, elaborate, and delineate the historical, social, scholarly and spiritual importance of their work, with little prodding from me. I realized later that none of these men were even half as successful in the art world as the women I interviewed, but they certainly talked a much bigger game.

I went back and asked Holly Roberts, one of my interviewees, about this. She had just had a monograph of her work published by Friends of Photography, received an NEA grant, and been shown at the Pompidou in Paris. "My interest is to get it done," Holly said. "I have two small children. I have to be very practical."

I've also noticed that women painters seem to be behind women writers in their outspokenness and recognition. I remember twenty years ago carefully listening with my women writer friends to a lecturer to see if he dared not mention women in his litany of great American contributors to literature. We would have protested right on the spot; he knew it and was properly nervous, and we exalted in that power. In Taos, I only hear references to the great lineage of the founding fathers, the Taos Society of Artists: Victor Higgins, Herbert Dunton, Ernest Blumenschein, Walter Ufer, E. Martin Hennings, Oscar Berninghaus, when, in fact, Blanche Grant, Mary Ufer, Ila McAfee, Mary Greene Blumenschein, Gene Kloss, and other

women were painting at the time and Catharine Carter Critcher was even in the society back then but is never mentioned. I have never even heard a cough of disapproval from the current Taos women painters about these women's exclusion from this lineage.

Barbara said to me, "Most of the women artists became wives and mothers. They didn't have the time it takes to paint."

I responded, "But, Barbara, in the late sixties we women writers said the same thing. It turned out that the women writers just weren't known. They were still doing it. We started to research them, dig them out, publish them."

"Where can I find the women painters?" Barbara came back. "Tell me that. How can I research them? Their paintings weren't reproduced in a book. They might have existed way back then—they probably did—but how do I get to know them and see their work?"

I was quiet after that. I stopped pitting my industrious women writers against the visual artists.

In October, I was the keynote speaker at a women's art conference at the University of Arizona. When I asked the audience to name twenty women writers, hands shot up. The women named—Virginia Woolf, Sylvia Plath, Toni Morrison, Eudora Welty, Alice Walker—were familiar to everyone. They'd won Pulitzer and Nobel prizes. Their books were in the university bookstore. When I asked the audience to name twenty women visual artists, the hands went up more slowly. When I called on someone, she named a painter I'd never heard of. I asked the audience if they'd heard of her. They shook their heads silently.

I recently bought a wonderful anthology about friendship, written by women. The cover painting showed two women sitting on a couch. *Hmmm*, I thought, *I like that; it looks like a Milton Avery, a painter I adore*. But that couldn't be possible. A book so attentive to women's issues, written by such strong, articulate women, putting a male painter on the cover? Surely they would want to support

a woman painter. Surely they could find a juicy painting of close friends done by a woman. I opened to the book credits: Milton Avery. Just then the phone rang. It was my friend Kate O'Neill.

I blurted out to her, "Tell me, why is it women artists are still unknown? Why have women writers gone so far ahead of them in the world?" She was working on her doctoral dissertation in feminist psychology.

There was a long pause. "Well, I called to see if you want to go to the movies. There's finally a good one playing in Taos." She paused again. "Do you really want to know?"

"Yes," I said.

And she reeled this off: 1. More women are writers because it is something you can do in secret or private. It is much more threatening to create visual art because there is much more exposure; a painting or sculpture is out for anyone to see right from the beginning, and women haven't had much public support. 2. Anyone can afford paper and pencil, but to paint you need money and you have to take up physical space. 3. Many renowned women painters had a man behind them. O'Keeffe had Stieglitz, Frida Kahlo had Diego Rivera, Elaine de Kooning was with Willem de Kooning. 4. Women can support women writers. A book is affordable. Paintings often aren't. Men, usually the holders of money, buy male artists' work.

Her analysis was so deliberate. The idea that stunned me the most was the one about taking up space. I'd made a religion of writing in cafés—not having my own studio, making it egalitarian, nothing special, everyone can do it. I lugged my work from restaurant to library to coffee shop. Was I afraid of occupying my own dimensions, of actually pushing out walls for myself?

The next day I told Barbara about my conversation with Kate.

I was impressed that Barbara had built her own big studio, that she wasn't trying to paint in her kitchen between the dishwasher and cutting board or in the back room she used as guest quarters.

Birchwood Cafe, Minneapolis, 2002

"You know what else about that list?" Barbara went on. "Painting is technical. There're all kinds of things to learn that aren't taught in public school. Everyone, at least in this country, has the opportunity to learn to read and write. The technical skills for a writer are built in from first grade."

"Well, where'd you learn the technical stuff for painting?"

"I studied art at a university and although I was recognized for my talent, there was an unspoken snag: I was female and was 'probably just going to get married.'"

38

BARBARA HAD BEEN brought up in Cambridge, Ohio, which is a small town fifty miles from the West Virginia border. I suggested that she visit her childhood home and render it on canvas. I imagined the expansive gray skies, long horizontal lines of railroad tracks crisscrossed by telephone wires suspended from tall vertical poles that seem to hover in the air. I had a romance about the Midwest, the heart of our country.

She smiled. I could tell she wasn't as interested as I was, though she carried the Midwest in her. I could feel it in her dedication to family, her even temperament. Against that sturdiness she was able to open up the spectacular colors and landscapes of her canvases.

Each afternoon through that spring and summer, when I visited her studio, I took in simple things about being a visual artist. Her palette was a big piece of Plexiglas, and she squeezed paint from many tubes onto the edges of it. Similar shades were next to each other. For instance, five shades of red would be in a row and while she worked she could blend with her palette knife two of those reds in the middle of the glass to create yet another shade of red—or an orange by adding yellow, or a purple by adding blue.

Northern light from a window fell on her easel; she said it was the truest and didn't cause a glare. She painted only in daylight. Electric

lights gave a fake sense of color, she explained. Her oils were done on linen canvases that cost as much as seventy-five dollars apiece.

These might sound like elementary things I learned, but I did not know them and they gave me a simple grounding. It's easy to underestimate the beginner's need for fundamental knowledge in order to feel at home in a new environment. A painter's studio was foreign to me. I took in Barbara's studio slowly, the way a dry sponge absorbs a puddle. Besides slides, she had a photo of each painting that she kept on three-by-five cards, and often she would photograph the same painting in different stages of completion and compare an earlier photo with the present incarnation of the scene she was working on. Sometimes she drew with an oil pastel directly on the three-by-five photo to see the effect of certain colors.

Perhaps all artists don't use this photo technique, but I was learning how one specific person approached her work. This is how I learn, not in the abstract but by plopping myself down in the actual real details of someone's studio.

Now, when I teach writing, I understand that students need to ask the simplest questions: "Well, where do you get your ideas?" (They ask that one often.) I can't just say, "You know, I think 'em up." Instead, I say, "Take out your pens. You have ten minutes to write down everything you know. Begin with the phrase, 'I remember' and continue. If you get stuck, write 'I remember' again and keep going." By doing this they experience their minds in the act of creating; they see how ideas essentially come into existence.

I watched Barbara and slowly tasted one artist's practical knowledge. And it stood me in good stead. Later that fall, I visited Holly Roberts in her studio in Corrales, just outside of Albuquerque. I was able to look around and say, "Oh, you use a narrow spectrum of colors on your palette." Of course this was only in comparison to Barbara, but it was a beginning, a way to enter Holly's practice.

And she nodded yes. "I tend to stay in certain shades."

"And you don't paint on linen. You paint on photographic paper. How does that work?"

"It's more fun to paint on it; it's almost like painting on glass or doing fingerpaints."

Her work was not an enigma to me because I could approach it with a knowledge of Barbara's. I had something to stand on.

90

NELL SCHWARTZ, THE main character in my novel, was becoming a painter. In one chapter, she has a great breakthrough and paints Taos Mountain. The inspiration for this painting of Nell's was Barbara's work.

"Gray on the mountain. Then purple. Then some blue. And green tinged at the base. A yellow sky the color of ripe pears. Then I made the yellow a bit brighter...There was a rich blue-black at the top of the ridges and a gray-black wash in the center of them ... And at the edge where the ridges touched the yellow sky there was a thin line of flaming orange."

I also had Nell paint a Basho haiku on canvas and then paint over the haiku with a totally different scene, using the words as a jumping-off point. This idea came from Holly Roberts's technique of painting over photos that she had taken, so the photo became almost invisible except for one or two elements.

Then a friend sent me a book of Helen Frankenthaler's prints. I studied them closely, first looking at one of her abstract pictures, then reading the title, then looking back at the picture. Three black, amorphous forms on a brown background were joined by a yellow line, a red line and a blue line. I liked the picture fine, but then I read its title: *Connected by Joy*. I felt a leap in my heart. Yes, yes, of course. Words did have a place here. The title intensified and deepened my pleasure. Another Frankenthaler print was entitled *Postcard for James Schuyler*. This gave my writing mind an idea. I'd

have Nell paint postcard pictures to friends of hers, keeping that person in mind as she worked.

38

IT CAME TO me one day as I finished a tough chapter in my novel that Barbara Zaring should paint the cover. I presented the idea to her that afternoon.

"Okay, I'll try. Let's see what comes up."

I gave her the manuscript to read. She knew well the territory I wrote about. We went out in October to take some photographs of possible scenes. Then after not seeing her for several weeks, I walked into her studio one afternoon to find the painting done. It overlooked Valdez, from the Rim Road, where the town's yellow fields and a few scattered sheds with long, low white tin roofs were in the center of the painting. Luxurious mountains of blue, green, purple, red, pink were in the distance, and in the foreground were bushes of red, green, dark blue. I knew these to be chamisa and sage. Above it all, dark birds, probably ravens, flew against the big blue, dashed with white, yellow and pink, sky in gestures of great freedom and joy. This was exactly the place in the book where Nell, the painter, met her soon-to-be best friend, Anna, the writer. They both wished to fly and watched sparrows, magpies, any feathered creature with wings, to learn how.

My novel's life that I had carried around alone for so long inside me leaped from the colored canvas—and the Taos landscape, the painting's root, was also the same place the story sprang from. I felt worlds come together.

Green Moon Red Trees, 2004

LESSON EIGHTEEN

Yesterday I pulled out of the cleaners heading north in my car on Old Santa Fe Trail. I wish you could have seen the cloud I saw through my windshield. It was big and floating and a soft square shape. All white, and the sky all blue. That alone would be enough to take you out of your busy day. Just that.

Take two colors. Make one color the form and place it anywhere you want on the page. Make the other color the background. Keep it simple. Do several of these. Have fun, and maintain a certain curiosity. What can you discover? Can you make anything as fundamental and satisfying as that single cloud in the sky? Of course, on the page we are not shooting for the cloud, but a shape on paper that has its own loveliness.

Victor Higgins' House, 1975

BEYOND FORM

ON NOVEMBER 29TH, I FINISHED BANANA ROSE IN SANTA FE AND IMMEDIATELY DROVE UP TO TAOS, PLANNING TO SIT THE ROHATSU SESSHIN AT THE ZENDO ON EL SALTO MOUNTAIN. Rohatsu is an important seven-day meditation retreat that begins on the first day of the month of least light and ends on December 8th, Buddha's enlightenment day—the day he became fully awakened under a bodhi tree at Varanasi, India, as the morning star arose in the sky. So it is a moment of great light in the month of great darkness. At many zendos, they sit through the night on December 7th until the morning of the 8th. I especially wanted to sit this sesshin, because I was still feeling confused about Roshi's death, and I was hoping this retreat would help shed some light on that, as well.

On November 30th, I woke up in my house on the mesa far from people or stores and I was very, very sick. I'd heard that a flu was roaring through Santa Fe; that was probably what I had, but no name could name how bad I felt. Writing this in July, it seems impossible to describe or even comprehend how sick I was—how quickly we forget what we do not want to remember! I do recall that I could not move; my throat, ears and nasal passages had completely swelled up and were throbbing and I couldn't stand up. I thought, this is definitely the end, and then I thought, good, I can't take this.

The phone rang. It was eight feet away. It was impossible to get over to it and pick up the receiver. It rang nine times—a hopeful friend must have been at the other end. Then it stopped. I had no aspirin in the house, no throat lozenges, no cough syrup, decongestants, Chinese herbs, homeopathic remedies. I just lay there, a being in an immobile body.

At about noon, my friend Joe Hoar, who has a house farther in on the mesa, knocked at my door. He'd seen my car and come to visit. He looked in the window. I motioned from my bed that I was sick; his face fell—he could tell it was bad—and he went to get the hidden key to let himself in.

"Wow," he said, standing over my bed.

Yes, I nodded.

"What can I do?" he asked.

"Aspirin," I croaked.

"Okay, I'll get you some. And tea. I'll make chicken soup. Liquids. We have to get liquids."

"Joe, I think this is the end."

He laughed, but I didn't. I was serious. He left to go to the store.

The phone rang. I crawled to it and managed to get out a deepthroated imitation of "hello." It was my friend Jean, who was also going to sit the sesshin. She said, "Oh, my God. I'll send Bob. I can't come over right away."

I hung up.

Bob came. Joe came back. Nancy Jane, my acupuncturist friend, came and gave me a treatment. I had flu medicine of every shape and form spread out on my bed. There was even Pepto-Bismol, which I hadn't seen since my childhood. Nothing helped. I lay there hour after hour. The phone rang. It stopped. The sun moved across the sky and night came. The first day had passed.

I was blasted awake the next morning by the phone ringing again. I was no better. By the third day I was able to roll over on

my side and read Ken Wilber's *Grace and Grit*. His wife, Treya, was dying of cancer. I was amazed at the energy she had to fight her disease. The way I felt just then I knew I'd give up.

For the next week I just lay in bed alone. This is some retreat, I mused. For hours I'd look at the ceiling and think of only one thing: I'd like to learn how to paint without lines, without drawing a picture first and then coloring it in. I would think this over and over. Yes, an odd thing to think on your deathbed. This time I wasn't subliminally wanting to figure out writing; this was directly about painting, my painting, and it felt raw and immediate. Fear rippled through my body. How, I thought, does a painter just paint? Where does it come from without an outside image—a horse, a plane—to draw first? How does one trust standing before a blank canvas? Each thought brought more fear. I am afraid, I told myself. I am afraid of the void. I am sick because of my fear of it. I want to paint without lines. Others have done it. Why should it be so frightening?

By the end of the first week, I could walk around a little. I was not going to get well quickly. I wasn't even sure I had the flu. Only one friend in Santa Fe had anything that sounded similar. We began to talk on the phone every day, comparing symptoms. She was having night visions, understanding things her Tibetan meditation teachers had said years ago.

I went over to my bookcase and pulled out a heavy book of Richard Diebenkorn's paintings. I went back to bed and propped it up on my lap. Page after page of *Ocean Park*: number 19, 21, 24, 27, 28, 37, 45. Each painting had different colors—oh, such colors! I looked closer. Color over color, next to a surprising other color and straight lines and not straight lines. How did he do this? How did he move so deep into himself and into the landscape of the canvas and into the space of the oceanfront in Santa Monica where he lived?

I looked at that book every day in the month of December. I was still sick, only well enough to go to the store or the acupuncturist. I

was having a relationship with Richard Diebenkorn. I'd write letters in my head to him: Dear Richard, I like your paintings. Dear Richard, I love you. How did you think of that turquoise next to that blue next to that orange in *Ocean Park* number 40? Dear Richard, I want to be a painter. Dear Richard, Your paintings continually surprise me. Thank you. I want to be your friend.

Then I'd change his name, imagine we were already on close terms. Dear Dick, I'd say, or Dear Rich. I was getting a little daffy. I wanted to know something I didn't know and I wasn't sure how to get to know it. I intuited it wasn't as simple as taking painting lessons. And the fear I felt told me it wasn't all about painting.

I wanted to understand how structure could come from deep within and emerge, not be imposed. I didn't want to rely on drawing something I saw right before me to create my structure. My psyche was trying to tell me something it couldn't say point-blank: "Stop holding on to what you already know, the old forms, the past. We're moving into new territory. Let go and start moving. We're going someplace else. If you hadn't noticed, Roshi died. There's no one here. There's nothing to hold on to. Go out there into open space and be born again in a whole different way."

I knew that what was happening to me couldn't be understood through logic—or through therapy, either. I had to go to an empty white canvas and find out what was within me. I also knew that what I was looking at in the pages of Diebenkorn's book took a whole lifetime to develop. If I wanted to paint like that, I'd have to give it everything.

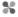

I GOT WELL slowly. By the end of December, I could keep my daily appointments if they weren't too early. I'd wake, get out of bed, and then collapse in a stuffed rocker at the opposite end of my room. I'd sit there for a while, stunned at being alive, and then I'd reach for

socks and slowly put on my shoes. Whatever I'd caught lingered through the end of January. I felt wobbly, unsure of my footing or of my immune system's ability to keep at bay any cold, cough, or sore throat some passerby might have.

And then in late February, walking down Kit Carson Road in Taos, I stopped in at the Del Fine Arts Gallery. I stepped into a room of chalky white acrylic paintings with backgrounds in all shades of blue. One was called *Down to the Bones*; another *Mercy*—I can relate, I thought. The artist, Julie Sullivan, used layer upon layer of color—you could see it if you stepped close—but the result was something simple, naked, with lots of white. I walked slowly from one painting to another. The gallery was empty. It was a cold day. I understood that what the artist had to say emerged by layering paint and that form emerged out of color. Something over time emerged from the void. I was certain she titled her paintings after she was done.

I went back every day for a week. I brought friends to see the show. On a Sunday, I bought a painting called *To the Light*. Then I asked Dana, the gallery owner, if I could call Julie Sullivan. She lived in La Cienega, near Santa Fe.

"Would you teach me to paint?" I asked her on the phone.

She said she hadn't taught much, but she invited me out to her house the following Tuesday. I detected a Wisconsin accent—was she from my beloved Midwest?

This time I wasn't going to a painter to talk about painting. I needed fundamental things. We made a list: eight brushes of different sizes, single-edge razor, gesso, a palette (I was going to tape a sheet of glass onto a card table), tubes of acrylic paint (I could pick out colors I liked at Artisan's on Canyon Road), palette knife, a sponge, medium-weight watercolor paper—I was used to cheap sketching paper; this was a leap for me—a few old jars, and some newspaper. In all my years of painting, I had never upgraded anything, for fear it would inhibit me or make me self-conscious or seem

too complicated, but I was willing to go along with Julie, because there was something I wanted.

That first afternoon at her house she showed me some basic things: how to clean my brush so the paint really got out and didn't leave the brush stiff; how to mix colors with my palette knife; how to clean the palette with my razor; how to gesso the paper. She explained that for acrylics it wasn't necessary to gesso the paper, but she always did it because she used to work in oils. Then finally she showed me the simple act of applying the paint to paper: You put your brush in the color you've mixed on your palette, carry it over, and spread it on—wherever and however you like.

The next week was at my house.

"Now, just begin," she said. She sat down next to me and looked through the Diebenkorn book, so I wouldn't feel self-conscious. I stood over one card table where I had taped down my paper, the other card table, now glass-topped, to my right. I put down long strokes of black, then blobs of red. I hesitated, then remembered what I knew from writing. "Don't think. Just do it." I kept going. I ended with a lot of paint on paper and what looked like upsidedown umbrellas.

Julie lifted her head from the book. "Good," she said. "Now do another one."

I began with gray and added blue. There was so much empty space. It was exhilarating—and scary. I grabbed a yellow pastel stick and drew cross lines to the blue shapes. I was going toward something and I didn't know what.

Julie had to leave. I walked her to the door and then went back to the painting. Triangle over triangle floating in space; then squares, then rectangles.

What did it mean? I had no idea. But what was important was that I was facing what I'd feared so much lying in bed with the flu: to just get out there in open space again.

Julie came to my house four times. After that I did not continue. I don't think I was ready for those lessons to take hold. I had set up a little painting studio in my basement and I felt isolated there. Writing was lonesome enough, I thought. After my first exhilaration, I avoided going downstairs to paint.

Then a year later, at the end of a book tour—I even remember the date, March 31, 1993—I grabbed the *New York Times* as I took a cab to the airport. On the front page, in the lower middle section, was a photo of a man in a western-type shirt, sitting wide-legged on a chair, leaning forward, his elbows on his thighs, his hair dark with a swatch of white in the front, and a white moustache. He looked tired. He was staring straight ahead, a ladder to his left, and on the white wall behind him were two square abstract paintings. The large headline read: "Richard Diebenkorn, Lyrical Painter, Dies at 71." I felt my heart squeeze closed as the cab sped along the freeway. No, not him.

I read the lead paragraph: "One of the premier American painters of the post-War era, whose deeply lyrical abstractions evoked the shimmering light and wide-open spaces of California, where he spent virtually his entire life, died yesterday at his home in Berkeley." Not you, Richard. My breathing caught in my throat. I read further. He was modest and cultivated no circle or school around him, unlike other successful artists. The Times said that he even hunched his large frame to make himself less imposing and spoke haltingly, often correcting himself.

I looked out the window. Traffic was thickening. The obituary went on. He lived in his later years in northern California, where he could look out his window to mountains and vineyards. The land reminded him of Provence, the place that inspired Cézanne, one of his heroes.

I've been there, Richard. I've even seen Cézanne's studio. His other hero was Matisse, the *Times* said. I love Matisse, too, I told him. Richard, you should have had more time.

I looked out the plane window the whole ride home. We flew above thick white clouds. During that flight, I resolved to attempt to do abstract paintings again.

There was something I needed to learn before I would really break out of my usual way of painting, and I thought I knew what it was. I had to be willing to paint really ugly pictures. I do not mean the subject matter—scenes of rape or blood and guts—as much as a willingness to use colors I thought hideous or to put colors together that I found repulsive. Otherwise I would remain stuck.

In writing workshops, I have often told my students, "You must be willing to write the worst junk in America. Go for the jugular. If anything scary comes up, follow it; that's where the energy is." Yet when it came to painting, I did not follow my own advice.

My paintings were dedicated to simple visual pleasure. I followed the god of beauty, not depth, albeit my personal idea of beauty, what pleased me. For instance, the combination of red and brown: placing those two colors next to each other or basing a painting on those two was so offensive to me that it could cause me to put down my brush and quit painting altogether.

When I went to college in Washington, D.C., every week I'd go alone to the Phillips Collection. I'd walk up to a particular Mark Rothko painting and stop. It was a red square on a red background, and above the red square was an ocher square. Both squares had softened edges, and all three—the red background and the red and ocher squares—seemed to intensify each other. There was a sense of shimmering, vibrating being. Just being. I felt I knew Rothko, like an old friend somewhere back in public school, fourth grade. Then right around graduation I'd heard he committed suicide. A fourth-grade friend whose life had gone amok, but there in that painting was his glowing life. Not only his life, but life itself—the heart of it—right on the canvas before me.

Even now, thinking of it, I ache in my chest. How could he

express so much, know so much, and then kill himself? I wanted his knowledge to make him happy. I knew that was naive of me, but I loved Mark Rothko because of that painting. It stopped me dead, made me quiet down, and one Sunday afternoon at the gallery, a haiku I'd known from high school sprung into my mind.

These red flowers of the plum— How red, how red they are, How red, indeed! (Izen, translated by R. H. Blythe)

And just as I was getting saturated with red, the ocher in Rothko's piece pushed me away, woke me up again so I could keep on discovering red's depths. It gave me waves of feeling. Yet, I would never have put those two colors together. In my own painting, I would have thought it awful—all that red next to that deep gold—two other colors I found offensive together. I was full of opinions about what belonged with what, and this imprisoned me.

After I'd been home from the book tour for a month, I decided to take a three-day workshop, entitled The Painting Experience, with Michell Cassou and Stewart Cubley. I had read that they believed the power of painting lay in the creative process, not in the product, and they encouraged their students to step into the void of the white page with the spirit of exploration. I had a strong feeling they could push me beyond my bonds of beauty.

"Nat-a-lee." Michell came behind me as I was poised, brush in hand, in front of a piece of blank paper. She was the teacher and now I had to play student. I wasn't sure I was going to like this. In her staccato English dosed with a heavy French accent, she said, "What is holding you back? What if a crazy lady painted this picture? Let yourself paint and do not worry about the results." There were thirty of us in smocks, our papers pinned to the walls. I dipped my brush

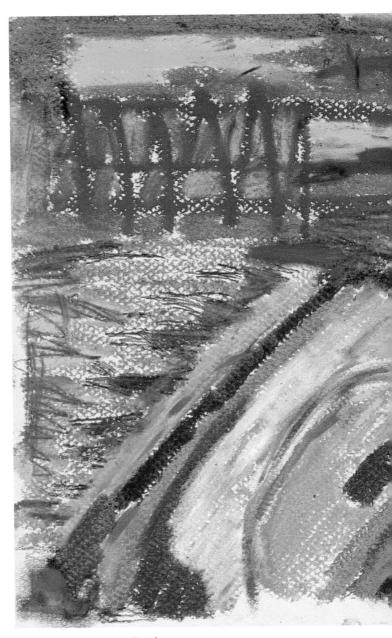

Landscape, 1995

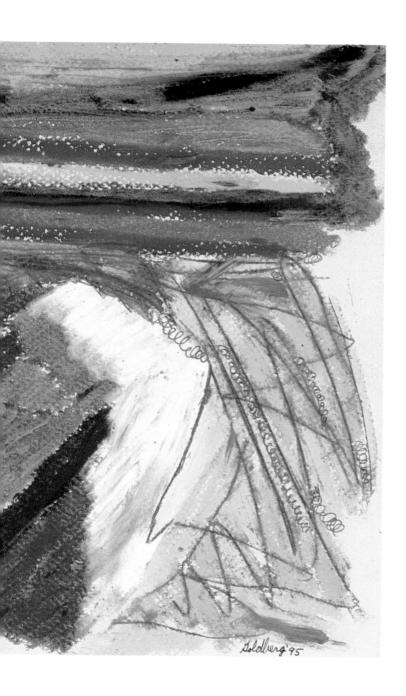

in brown. I was going to paint a tree—the crazy lady would like a tree. Then as I was in the middle of relaxing into my "pretty" scene, Michell snuck up again and asked, "What could you do if you were not afraid of ruining this? Go ahead, be brave, do it."

I wanted to ruin her, to turn around and smash the brush over her head, but I'd traveled all the way to San Francisco to learn from her, so instead I surrendered to her suggestions. I made the tree bleed. The bark was brown and I grabbed red for blood and was throwing it on. I froze. Brown and red. No, not that ugly! I had definitely ruined my picture. And then I added red to the leaves—they were bleeding, too. Ugh, green and red; it looked like Christmas!

Stewart came by. "I hate my picture," I told him. "Those colors together—nothing could be worse."

"Well, could you paint from those negative feelings? What could you add?" he asked me.

I hesitated. Then I dipped my brush in black and painted a stickfigure man with a big penis fucking the earth. Ah-ha, that broke something open in me. I painted blue gorillas ripping off doors and heads, sharks sawing off a meditator's limbs by a stream. All with lots of red blood over brown earth and brown meditators with the bleeding trees around them.

By the end of the workshop I felt exhausted and free, but I was still haunted by my urge to create abstract pictures. I went up to Stewart to ask him how I could paint them.

He said he thought the idea of abstraction was arbitrary and that most paintings had both abstract elements and images in them.

I understood his point, but even so, what about Kandinsky, Helen Frankenthaler, Agnes Martin? What about De Kooning, Joan Mitchell? What about the surface of a river pebble, the texture of a branch, the back of my hand? Perfect color, line, gradations of light and form, but without a name, a label—this is a house, and over here, a flower—just is-ness, center, without being anything, speaking

directly and bypassing my image-making brain. When I looked at a Jackson Pollock, I felt as though something had stepped out of the skin that contained it and approached me raw, from the inside.

I understood that human beings were comfortable making meaning, creating with language and pictures things they recognized and that validated their lives. But now I wanted direct comprehension of what it meant to be alive—wordless, unarticulated, through the inner cells, a knowing beyond our ordinary way of knowing. When Roshi died, I no longer could understand in the way I previously had, and that's when I began to respond to the abstract in painting. Perhaps if I learned how to paint that way, I could express the deep presence I still felt from my teacher, even though he had been cremated and no longer lived in the world of form.

30

ONE DAY I was at Barbara Zaring's studio when she took out two paintings she had done a while before and planned to exhibit in a new show.

"I didn't know you did abstractions," I said. "I want to know how." I felt jealous, an emotion I am blessed not to feel often. "Do you think you could explain how you did them?"

I went to her show many times and found myself always stopping in front of those two paintings. One was entitled, *Pink Is All the Rage*. It was a tidal wave of pure hot pink about to explode and take with it the whole paper, royal blue on the right and a cooler green on the left, but even with the green, I never got to relax because the pink was flanked by raging red. All the colors were pulled in to express passion at its full, essential moment. At the gallery, I would lean so close to study the painting that sometimes my breath would fog the glass. And there are no lines, I'd think. No squares or triangles, circles or rectangles. It was as though Barbara was able to ride on the pure ecstasy of color and leave form behind.

The other abstract was called 100 Ways to Get to Gray. Ah, my favorite color! Barbara had told me, when I asked about the title, that there are many avenues a painter can take to create gray. She said the dullest was mixing white and black or simply using a tube of it all ready-made.

I looked closely at the painting. Indeed, there were many warm and cool grays in that picture. I asked her how she made them. She said one of her favorites was mixing alizarin crimson and viridian or phthalo green.

My eyes widened. "I've never heard those names before." I thought of the hundreds of tubes she had in her studio and all those color names she had access to.

"You can mix any opposites on the color wheel to get gray: red and green, violet and yellow, orange and blue. You have to add white to it. In this piece, I also crossed media to come to gray." She pointed to the upper left. "I put down white acrylic and then overlapped it with graphite."

In Barbara's gray painting, a different explosion happens than in the pink painting. In this one, the grays fall back away, and an inward explosion is felt. Something deep in its own center has imploded and the result is a brilliant white that floods outward, oddly, conjuring up the amazing bloom of pussy willows on a cold March day at the end of a dark season.

Six months after her show, I asked Barbara if I could come over one afternoon and paint.

She gave me a seat, space at a table, and spread out acrylics, dry pastels, and oil pastels, at least a hundred colors. The colors alone lit my heart.

The only instructions she gave me were, "If you put oil pastel down first, you can't put dry pastel over it. It won't stick."

I nodded. I didn't know what she was talking about. I was so excited, I just reached out for a square stick of pale orange and drew

a line across the page. From that line I built a turquoise line next to it, and then an orange across it. I reached for a brush and dipped it in red and made a smush in the corner. One act at a time, I tried to let things breathe—me, the medium I held in my hand, the paper.

Barbara worked at her easel across the room. We chatted. I didn't look at what she was doing and she left me alone. This felt good.

At one point, I was stuck. I didn't know what to do next. I remembered a video about Matisse that I had seen recently. He had said that whenever he wasn't sure, he went for black. I'd always thought you weren't supposed to use black. I reached for it and felt free.

It wasn't a good painting that I did, but I was happy, because I knew I'd broken the code. I could sit in one place for several hours and be engaged simply in the act of pushing color, line, and form across the page. It was the beginning of my entry out of the phenomenal world.

There is a Zen story about an old monk who practiced for more than forty years in a monastery and then became disgusted—*I'm getting nowhere*, he thought—and decided to leave. As he walked down the path to the gate, with his few belongings on his back, he noticed that the walkway looked a bit messy. He went to get a rake to smooth it out. As he raked the dirt, one pebble flew out, hit some bamboo standing nearby, and made a sharp sound. The instant the monk heard that sound, he became fully and completely enlightened.

As I put away the brushes and paints, I wondered what it was the old monk understood. Was he able to see through the end of death? Could moving deeper into nonrepresentational form and the pith of color carry me into the essence of who we are and what it means to be alive and die?

I realized I had changed my relationship to painting. I was now going to it as a path, a way to see clearly. It was no longer just something easy I did when the work of writing was finished for the day. Previously, I had always felt strongly that it was important to take on

one practice, as a place to chew and digest my life and go out beyond any limit I had ever known, almost the way the prow of a ship prods and explores the waves ahead. My one practice had always been writing. I feared dilettantism: A painting isn't going well, I switch to a story I'm working on; the story is at a hard point, I go roast a turkey with fancy stuffing. Nothing comes to completion, and I back away from my own edge when things get hard. I'd watched it happen with my friends and students and it scared me.

But now I was going to painting with a fundamental need, wanting to work out my difficulties through brush, paint, form, and color. Writing had served me well, but I no longer had to be limited by it as my only tool. I had confidence in myself from having made writing a deep practice. I was not flirting with painting.

I felt gratitude as I left Barbara's and I was very, very happy that whole evening. As I made dinner and cut the carrots with a knife, I felt my hand wanting to grab for a pastel, to feel its weight and texture in my hand.

Then two months later—I was still working at Barbara's studio nearly every week—I found a book in an Albuquerque bookstore about the painter Arshile Gorky. I remembered Julie Sullivan had shown me his paintings one time when she came to work with me. I wasn't that interested in them then, but I examined them closely now. Many were oil on canvas but they looked watery and had odd amorphous forms and a certain jagged energy as though they had landed from outer space and were trying to communicate not with our minds but with our livers or gall bladders or pancreases. I also noticed that Gorky had beautiful titles for his paintings: Cornfield of Health II; How My Mother's Embroidered Apron Unfolds in My Life; Good Afternoon, Mrs. Lincoln; Love of the New Gun; Summer Snow.

I turned to the front of the book and flipped through the text, stopping arbitrarily on page 88 and reading a letter he'd written to his sister. Then I read it again. The blood became quiet in my body.

I was standing in a bookstore on a busy street, but a great calm pervaded everything.

Abstraction allows man to see with his mind what he cannot see physically with his eyes.... Abstract art enables the artist to perceive beyond the tangible, to extract the infinite out of the finite. It is the emancipation of the mind. It is an exploration into unknown areas.

Yes, that was it. I had been groping to express what was beyond my paintings of red trucks, chickens, houses, buildings, chairs, and tables. The material world was a fine thing, but it was no longer everything. There were worlds beyond worlds. When my teacher died, I knew he was out there where I couldn't physically see him, just at the edge of a chrysanthemum petal or in the moment I turned my head, in the flash between neurons, or in sunlight, or on a cold morning in the haze of a horse's breath. I wanted my paintings to communicate with him. I had to step out of form to do it.

LESSON NINETEEN

When I first attempted abstract painting, one of the approaches I tried was to choose a title first and then express the title without pictures, only using color, form, line, texture. It was like writing a poem without words. Occasionally, I'd open a book of poetry and willy-nilly grab a line-and that became a title. Most of the time I enjoyed making up titles, and some of them expressed what was going on in my life. The title could be as long as I wanted: How It Feels to Break Up with Someone You Love: Three More Lives to Live; Hearing a Friend Had Just Died. It helped at the beginning that the title was concrete. It gave a thin foothold, something to spring from. Anything was game to become a title. Sometimes I'd just look around a room-Cat on a Radiator, or Slow Moving Chicken-but the trick was I couldn't actually paint the cat or chicken. I would instead give the feeling of the day, the quality of light, and try to express the inside existence of a feline creature. Kind of crazy, almost fun, often frustrating. Frequently the title was better than the actual painting.

I've just given you ways to find titles. They can also come from a flash phrase in your mind. Whatever and however you come up with them, it's helpful to be specific. It creates a juxtaposition—a tension between the abstract and the particular—and

makes for a pleasing, lively contrast.

Now you try. Make a list of ten titles. Also be sure to jot down good titles as they come to you over time.

Look down your list. Grab one title that seems to call you, that has energy. Say it a few times, then pick up a tool and begin to express it. Be patient, yet daring. Don't be afraid to fail. Fail as much as you can. It will teach you to bounce back like a rubber ball. And a little failure in a corner of a page can end up leading you in a glorious direction, giving you something to work from.

LESSON TWENTY

Fill a whole page with color, one layer on top of another. Use several different mediums to see which ones enhance or obliterate the layers below. On top of oil pastel I sometimes paint gouache. The gouache adheres to the oil in the pastel only in little droplets, but it adds texture. I discovered this on my own. See what you can discover. Any number of people can tell you how to paint, but the only real way to learn is to do it yourself—over and over.

If you succeed in covering and layering a full piece of paper, this is called a color field painting. In a way I did this with Joan's couch on page 93, filling the entire frame with a color field. You might want to start with a smallish piece of paper to not get overwhelmed.

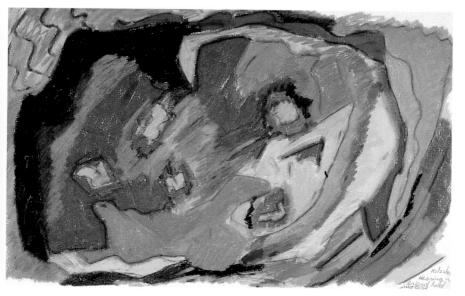

Hearing a Friend Had Just Died, 1995

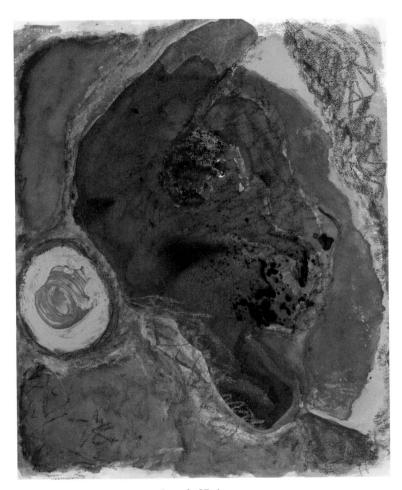

Sound of Rain, 2001

WALKING THE EDGE

MY PARENTS VISITED ME IN SANTA FE TWO WEEKS BEFORE I LEFT FOR FRANCE IN 1992. ONE AFTERNOON, I WANTED TO SEE AN ART EXHIBIT AT A NEW GALLERY THAT HAD OPENED on Read Street. I asked my parents to come along. We walked into the first room where we were surrounded by four Joan Mitchell oils, each the size of a wall.

My father stopped dead, seeing the paint splashed across the white canvas. "My God, I know how she did this. She used a cannon," he said. "She filled it with paint and fired."

He looked a little while and then got bored. He tugged at my sleeve. "Nat, my knees are hurting. Find me a chair. I'll sit and rest while you look at the other paintings."

I located a chair in a back room. As we walked to it, we passed another oil in the hallway. This time by the minimalist Agnes Martin, who lived in Taos, New Mexico. It was a charcoal gray canvas with black lines about one inch from each other going straight across.

My father froze. "Nat, is this a painting?"

Yes, I nodded.

"He better get a job. He's gonna starve." He turned and headed for the chair before I could inform him that it was by one of the most important *women* artists in America.

I rejoined my mother and continued to view the paintings. When I returned to my father and came up behind him, he was leaning over an art book on his lap that he had found on the nearby coffee table. He was so intent, he wasn't aware of my presence. He turned the page and studied the next picture. It was a book of Joan Mitchell's pastels, wild scribbles of exciting energy. I had seen them before at the Whitney Museum in New York.

I put my hand on my father's shoulder. He looked up. "Nat, is this painter here?"

"You mean in the gallery? I don't think so. She lives in France."

My father was disappointed. "Oh, I wanted to talk to her."

"What about?"

"I'd like to ask her what she thinks these pictures are. I mean, a horse? A tree? I can't find anything in them."

As we walked out, we passed the receptionist in the front room. I asked, "How much are they?"

"Three fifty," she said.

We were opening the front door. After thinking a bit, my father said, "Well, I guess those big canvases cost a lot and there's a lot of paint involved."

"Dad," I said. "It's not three-hundred-and-fifty dollars. It's three-hundred-and-fifty *thousand* dollars."

That price blew all his gaskets. He walked to the car in silence, got into the passenger's seat, and closed the door.

A woman from the gallery ran out, waving her hand. "I'm sorry. I was on the phone. I didn't get a chance to help you."

My father rolled down his window. "That's okay. I don't think I'll buy anything today."

And we drove off.

My father often voiced what others felt but were afraid to say. This time about abstract art: What the hell is going on here? I can't find any footing. This is art? Somebody help, explain it to me.

I was often exasperated with his quick dismissals, but also touched by his earnestness and blunt curiosity.

I wish you could have seen him in a museum when he discovered a bronze sculpture of cowboys on horses swinging lariats above their heads, reining in cattle. He repeated over and over, "Nat, this is beautiful. Nat, this is beautiful," with a deep New York accent, intensified by his enthusiasm. "How did he do this?" In that moment you could feel how art was for everyone, how it could spark our wonder and awe.

Later that night in Santa Fe, we were eating salad at the Coyote Café. My mother looked around. "We should have dressed up."

"It's okay, Mom. It's New Mexico. No one cares."

"Well, I do. I like to dress up."

I nodded.

We continued to eat. The silence was long, but I wasn't uncomfortable. In years past, when I'd had a need to share so much and for many reasons had not been able to, the long dinner silences were unbearable. But now I accepted the silence. We were eating lettuce, that was all. I was their daughter; they were my parents. The connection was a long blood line. That was enough.

The quiet between us became bottomless. I was almost finished with my salad. It was delicious.

My father put his hand over mine. I looked up.

"You know, Nat, about death." He paused. "Don't worry. It's nothing." He reassured me, and then we both went back to our salads.

At the time I thought my father's comment was a non sequitur, out of the blue. But now having painted in the abstract for over fifteen years I realize his questioning of those abstract paintings at the gallery could have catapulted him to thoughts of the finite—and infinite. Maybe not quite thoughts—he wasn't a thinking man—but he had instinct and a trust in his own sensate reactions. However wary he was of those paintings, they sprung him out of bounds to a fresh place. This man who stood behind the bar at the Aero Tavern

on Long Island, day-in and day-out, serving whiskey to the rough and tumble of Farmingdale, was capable of responding to head-on, stripped-down, raw communication when it appeared. It most likely wasn't conscious interaction, but something stirred. Something like Godzilla meeting a flower—what then will bloom?

What my father—and most of us—don't know is that we live on the edge of the abstract all the time. Look at something solid in the known world: an automobile. Separate the fender, the hood, the roof, lie them on the garage floor, walk around them. Let go of the urge to reassemble the car or to pronounce fender, hood, roof. Look at them as curve, line, form. Relax the mind. Don't immediately try to make meaning or be practical. Truthfully, how practical is life anyway? All our work, and death is the final result? So let's enjoy the unfolding shape, the elemental, organic delight and agony of it all.

Look at a telephone pole. I have one out my window. Yes, it holds up wires for communication, but it's also a line made from wood. (Think of the tree they had to find—that tall and straight.) There is a grey wall in front of my house indicating my property line—one mass of color running horizontal to the pole behind it. A few winter twigs of New Mexico privets jut out from behind the wall—little scratch lines against a massive blue space of sky.

Look at a cactus, a bench, a loveseat, a pond—don't name the objects. Take one step back into awareness and just look. Notice the movement, the structure. When I sit in front of someone to draw their face, I don't think Jean, Kat, Phil—or even nose, eyes, teeth—I follow the line of their lips without thinking "lips," the curve of the ear without labeling "ear." That's why doing a portrait is so intimate. You are deconstructing a face to see more truly into it. Only later, much later, do you think, "Alyce," and name the person again.

How do you begin an abstract painting? I can't speak for everyone. I still struggle with the beginning emptiness of the open page, the non-identification. But if I'm willing to face that—pick up a red pencil and make a line, a smudge, a cross of lines—I have broken through the vastness, made an echo, a trace in the void that I can follow. But even before a mark is made I need to consider the page itself. Where to make the first mark? The right corner? Upper left? Usually I work from the middle of the page out. I've extended my materials from gouache paints and a black writing pen to also include dry pastels, oil pastels, acrylics, and colored and charcoal pencils. I like to have colored tissue paper near at hand, as well as gold stickers, oil sticks, ribbons, shells, and sand I collected from the beach. I haven't used these, but knowing they are near helps to expand what is possible. And I am very timid in my materials compared, to say, Richard Chamberlain, who was known for using crushed car parts to create sculptures.

After I make my first mark, I make another—usually with a different color or a different medium. I try to let the painting unfold without direction. I let it tell me what to do, what it wants. I curb my urge to make "something" and instead keep the field open.

Playing music helps. It provides a place for the nervousness to rest so a larger mind can open up. I have to admit that after years of blasting Dylan I've honed my listening to a single chant track—the eighth and last on a CD called Now by Bhagavan Das. I press repeat on my boom box, which was given to me by my students at the end of a three-week retreat in 1995. They were sick of me using my cassette tape recorder from 1974 that I bought for \$46 to practice reading poetry aloud. This one chant that Bhagavan sings, Sri Krishna Arati, keeps things simple for me. When I hear it, my nervous system becomes attuned and it signals the work at hand. Also I don't know what the words mean—they are sung in Hindi—so the music immediately enters below conscious thought and meets unformed emotion. This is good. Once longing, sadness, desire, loss, joy, squeamishness, aching are ignited, they begin searching through my hand for expression and the work really gets going. I step out of time and unhinge

Knocking on Heaven's Door, 2001

The Great Spring, 2001

from ground and gravity, swimming into the heart of things—not always sweet, not always raw and terrible. Each time, a chance, a peril, a plunge if I'm willing to go with it.

The song I play in my studio when I paint was purchased one night when I was visiting my mother. I have always had a difficult relationship with my mother, but in her late eighties and early nineties she was alone in a small house in Florida. So in the spring of 2002, to eschew her loneliness, I committed to staying with her for the full month of March, planning to go to the local library each morning to work on a new book. It was the second morning there and I was already bracing myself for the long, slow days ahead with someone I held conflicting feelings for—a burning rage that flared whenever I was near her coupled with a deep compassion for a woman who had never been alone, and did not know how to manage at the end of her life.

To cope I looked hopefully at billboards at the grocery store: a yoga class a mile away. Glory be. My mother lived in a city called Green Acres. Ten miles in from the ocean on a straight road lined with strip malls, it was filled with retirement communities of identical houses and slow, white cars driven by seniors who came down from New York. I didn't care what kind of yoga it was. I went to the 9 A.M. class.

There were five students, one visiting from Indiana. The teacher mentioned he had hurt his back and hadn't practiced in two years, and then he barked out positions for us to take—downward dog, the flamingo, backward bend—with little instruction. I was glad at the end to still be intact. As I reached for the door I espied a white sheet of paper and black letters: Bhagavan Das singing here at 8:00. As in, 8:00 tonight. Impossible. Bhagavan Das was the wild man who Ram Dass (then Richard Alpert) found wandering in India, the American with long locks and a gorgeous, if unconventional, voice who is written about in *Be Here Now*, one of the major books that

led my generation into Eastern spirituality. He was coming to this sedate neighborhood, this tiny yoga studio near my mother's house? Maybe I got it wrong. It couldn't be him.

I had encountered him raw and rough in the early seventies when I lived on the side of Lama Mountain in a tepee. Lama Foundation was a place that honored all spiritual disciplines and I remember seeing him growl at his wife before entering the library there where he spent a long time exercising his voice from screeching to a whisper to high notes. I was weeding outside and heard the whole candid performance. He must be down on his luck, I thought. But, to be sure, I went to the studio that night, and it was Bhagavan Das in the flesh. He pulled up to the sidewalk in a white station wagon with someone called his manager and a few young hangers-on. His hair was still long and blond—if not also gray and tangled like a sadhu's—and he wore lots of beads and was dressed all in white.

A small group of suburbanites gathered. I sat in the back to witness this clash of cultures. Bhagavan didn't hold back. For a whole hour, he plucked an ectara and sang a single Hindu chant that played the full range of his vocal capacity. About forty minutes into it, a man in a white T-shirt and slicked-down black hair yelled out, "Bhagavan Das, you rock," and Bhagavan yelled back, "I don't rock, God rocks."

When I purchased a CD that night, I asked him to sign it for "Sarah"—there was too much pleasure in being an anonymous witness, not wanting to remind him of our meeting long ago. The anonymous name also signaled a combination of how far I'd traveled from my suburban Jewish roots, yet here I was sitting in the center of them in Green Acres.

20

IN EARLY 2000 when I was living in a tiny third-floor walk-up apartment in St. Paul, Minnesota, I decided to work big and begin with

a given shape on the page. I took a large sheet of good quality white paper and poured in the center some watered-down acrylic paint. I tilted the paper so the acrylic rolled around and created an amorphous shape. I did this with three or four sheets at a time and then left them on the floor to dry. Coming back a day or two later, I walked around, inspecting them. There was no fixed top or bottom. I chose one, put it on a table, windows all around me looking out on the tree branches and street below. I began to make a relationship, a connection with the form in front of me. I tried making a few squiggles with my pencil in a curve of the dried acrylic, a stroke of blue gouache across the top. The rule I created: Let the original form have its own integrity. Don't begin with it and then wipe it out. Whatever you do, let it live, let it have its own throb below whatever you add. Don't destroy its gravitas. In a way, this was exactly the same rule as in writing. What do you think the title Writing Down the Bones means? Honor the essential, the original, the first. In both painting and writing, you can work off of first thoughts, first impulses, but you can't wipe out or disregard the foundation, the essential bones. Where would civilization be if we did that? So I was doing my bit of respect with these acrylic splashes.

I had gone to St. Paul for a year and a half to study Zen koans. What I didn't realize at the time was the process of me attempting to understand and respond to the koans was a similar process to what I was doing with the paintings. The koans were devised as a way to wake up a student, to jolt her into experiencing a larger reality. With the koans, I had a given conundrum. For instance: Without thinking quickly, quickly what is your original face before your parents were born? How do you answer that? I couldn't say one plus one sums up to two. I had to go some place different from my usual way of thinking, outside culture and the confines of time and history. Similarly, with painting I had a given acrylic shape, but to make it work I had to go under, inside out, find my way beyond normal perception.

One late night in early April, an orange electric spring storm pounded the pavement with a ferocity found only in the Midwest. As the storm lit up my apartment windows, the right relationship—a roiling ease—sprung up between me and the form in front of me: not leaning too far forward or bending too far backward, not using too much color, not using too little line, not being cheap with pastel, not too rich with oil. During that week I did four paintings in a row that I was deeply satisfied with and their titles came to me naturally: Knocking on Heaven's Door, Sound of Rain, The Great Spring, Crossing the Yellow River.

I was also using writing practice during that time in St. Paul to attempt to express the koan by dropping syntax, much like I dropped form in abstract painting, hoping to touch some crux of essence in both. I found this in my notebook:

Quickly, quickly without thinking, give me your original face before your parents were born—no face at all, coming in from under a blade of grass a horse a ripe melon black hole sweet coconut, no thought no music no drop of dew no snow no street river tissue floor ground ceiling sky shoe shoelace sack elbow ankle wrist toe hair no kiss fuck love me no love no not love no rhythm no hell no sutra no book no computer phone library no Hemingway, Carson McCullers, Willa Cather no grave no James Baldwin no California no U.S. Syria Lebanon Turkey Asian tea ceremony no war no peace no thought no not thinking and no end and no beginning. No pencil no specific word name mouth pot to cook rice no dust the dustless the deathless truckless cell-less footless carless moneyless bank-less treeless.

Mountains of potatoes I throw at Hakuin my ancient ancestor and Hakuin throws them back at me. This very knee exists forever and has never been. These very eyes, this very heart. I am lit by this very life this life that is not my life and is no one else's life.

Three Circles 1, 2013

Three Circles 2, 2013

And then I see the mind settled, landing on my mother, maybe freer, more accepting, less attached:

I thought it would never end. The walking to the pool at night, the rough concrete on my bare feet, the soft sky and palm trees. She alone in the living room watching TV, the movement of light from the screen across her face, neither of us having anything to say to each other and not bearing to leave and go home across the country.

Recently I bought a 7×10 -inch spiral watercolor pad with the urge to do small, contained abstract paintings, one after the other, investigating I wasn't sure what. On the first page I painted three curved blue gouache forms. I went from there—turquoise over the blue in lines of diagonal paint; oil pastel lines in pink, orange, red; brown, green pencil slashes; grey scribbles. I built slowly. Work a little, step back for several days. Try to leave some breathing space, not fill in every spot. Add layer, texture, richness. My excitement often runs ahead of me and wants to fill in too much too quickly. Like a mother calling in her child for dinner, I try to pull back, but the child plays harder.

Waking at five one morning, I began the second one by drawing three circles with a pencil, holding the enthusiasm close, not letting it run ahead, but staying together. I considered a touch of lime, a slash of purple—apprehensive about purple—it's a strong color and can take over, dominate, so I used it judiciously.

On a different page, I began another with three circles—eventually wanting to try two circles, and then one—I morphed from the initial three curved forms and felt I had found a true root, though it was not rational. Why circles? Weeks later I recognized the small repetitive perfect spheres I doodle in the margins and on the thin cardboard covers of all my notebooks during longer pauses in writing. Why do I do this? What are these scribbles expressing? For most of my life, small hearts were what I drew in the margins. At one

point five years ago I was even writing a book with a friend entitled *Doodling Hearts*. I can't say when I transferred over to the circle. Did I give up on love and turn to world peace? I am careful not to analyze too much. What has meaning? A breeze in the trees, an ice cube on the counter melting? All I know is that these circles have now also appeared on my drawing pad and I accept them gladly as a way to enter the infinite, reach out to the impermanent and ineffable. A stepping stone to what I cannot touch.

Just this week I painted two rickety chairs with bright African cloth upholstery. The cloth design was circles, many circles, and I cannot tell you the pleasure of pointing my brush bristles into those repetitive disks. Dip in water, then orange cake, then paper, filling in one after the other. This act carries my eye to noticing the circle of the wastepaper basket, the round coasters of my chair, the base of the standing lamp, the ceramic cup on my table filled with pencils, the yellow tennis ball I have on my desk that I use sometimes on the floor to roll my tight shoulders, the legs of my table, the knobs of the closet door. I am surrounded by circles—the smoke alarm high on the wall, the bottle of paint remover. I never noticed this before. Our surroundings, our world—it is comprised of nothing less than abstract material. To be aware of this gives us more breathing space. Life is fluid, we can change, we can fail, we can move on. Nothing is frozen or solid. All is alive and transitory.

LESSON TWENTY-ONE

In the late nineties I was at Tassajara Zen Monastery for a week on my own. With a cheap box of six oil pastels and cheap sheets of paper, lattempted to make plain pictures of the natural scenes around me: a waterfall, a mountain, a range of mountains under a starry night, the old hot springs buildings of Tassajara tucked deep in the valley, mountains with distant trees and a vellow sky. I did eight in all, occasionally with my dear friend Katherine Thanas, abbot of Santa Cruz Zen Center, breathing over my shoulder. "Make it simple, make it real." and by real she didn't mean get an exact copy, but feel the line connecting to your eyes and to your breath and body. Get out of the way and let drawing do drawing, become falling snow-a light touch. Don't try to capture everything.

Sometimes I say to my writing students, become dumb, not complicated, not philosophical—alone, artless, guileless, straightforward, uncontrived. This works well, especially when you are trying to express something confusing, involved, mixed up.

This also worked well for me that week at Tassajara in approaching the abundance of the natural world by trying to do a landscape. In a way, keeping it simple is walking the edge of the abstract world, between what is in front of you and what is unknown, reduced to line and shape.

So now you try it. Go out to a familiar or unfamiliar landscape. Sit quietly for ten minutes with your eyes closed. Then open them and begin to draw with no past, no future, and no ambition. Keep it simple. You won't capture everything—don't even try. Use crayons or pencil or pastels. See if you can do eight landscapes over a few days time.

LESSON TWENTY-TWO

Always listen to music you love. It can juice you while you paint. And if you like, sometimes draw or paint that music—but this is not an exercise in illustration. At first it's best to pick music without singing, with no words.

Music usually reaches you through your senses—sound, sight and sometimes you can almost taste it. Create a picture with no images that expresses the sounds you love.

Now listen to people singing—folk, rock, hip-hop, country—your choice. Create a picture adding collage. Let the jagged juxtaposition of images in collage echo the words in the song. Not illustrating the words, but reflecting the feelings. Scissors, paste, samples of wallpaper, portions of pictures from magazines. Pay tribute to a songwriter, a composer, a musician you love.

Tassajara 3, 1997

GALLERY

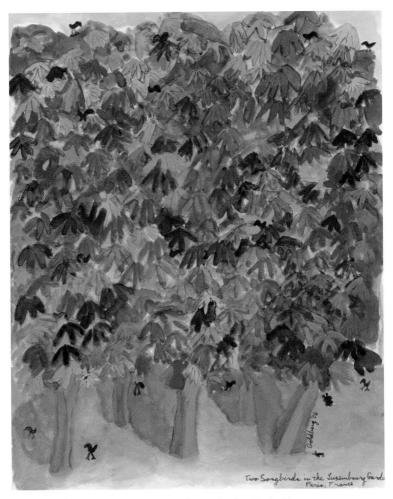

Two Songbirds in the Luxembourg Garden, Paris, France, 2006

Dark Pool, 2004

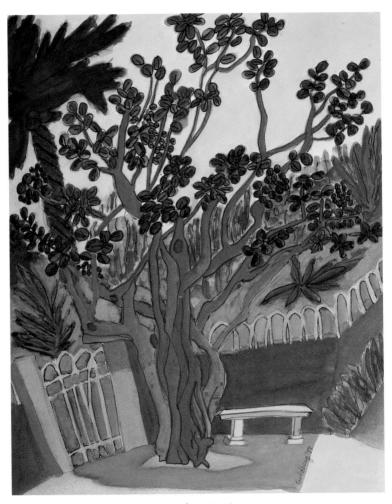

Seagrape Tree, Florida, 1999

French Rooftops, 2006

Blue Barn, 2007

New Mexico Horse, 2005

Three Houses, 2012

View From my Hotel Room II, Philadelphia, 1996

Two Chairs in Italy, 2013

Loveseat with Pillow, 2012

Louise's Chair, 2007

Cafe with Birds, 2011

Sugar Nymphs Bistro, 2003

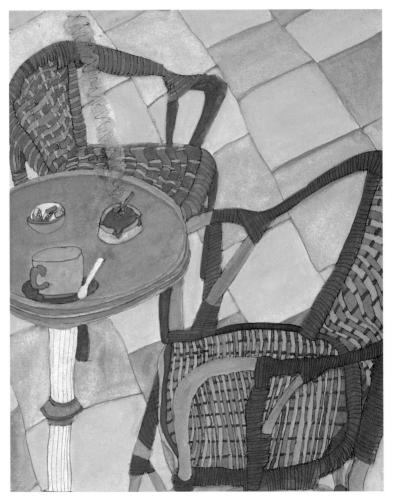

Two Chairs, France, 1997

Happy Birthday Chocolate Cake, 1995

Bubba's Diner, 1995

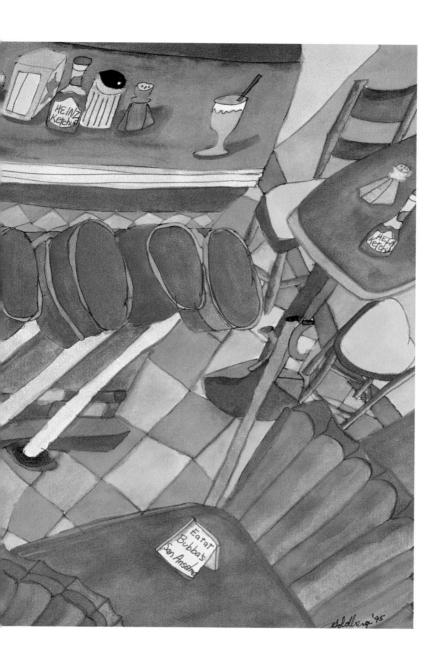

Chrysler Airflow, 1995

Dancing Rhythms, Fort Bragg, 1996

Schmidt's Brewery, 2003 (diptych)

Courtyard, 2005

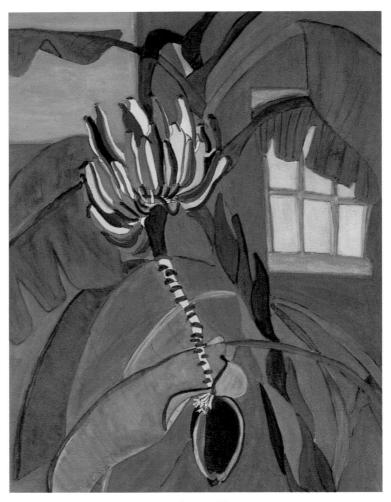

Banana Tree, Florida, 1998

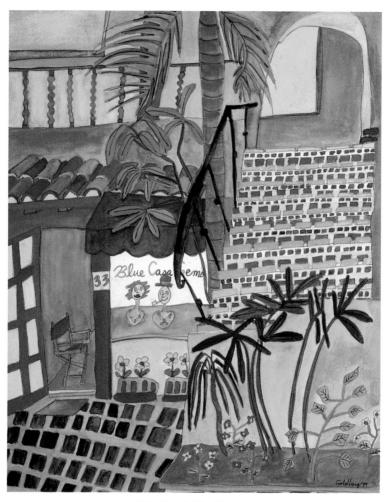

Palm Beach, Florida, 1999

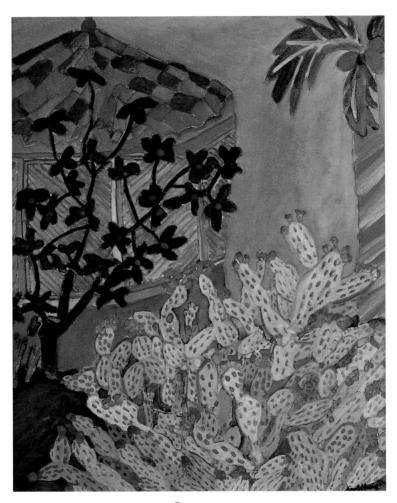

Cactus, 2001

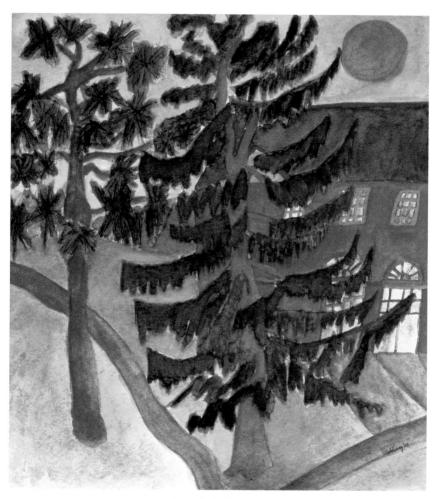

Trees in Ohio, 2000

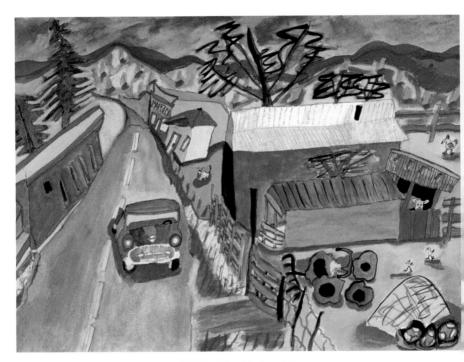

El Rito, New Mexico, 1995

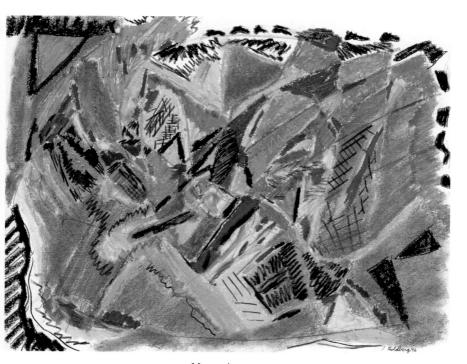

Mountains, 1996

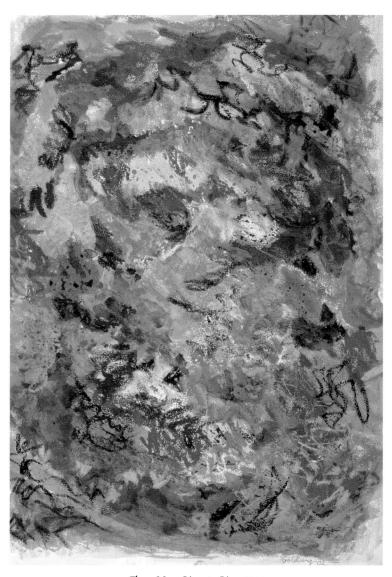

Three More Lives to Live, 2002

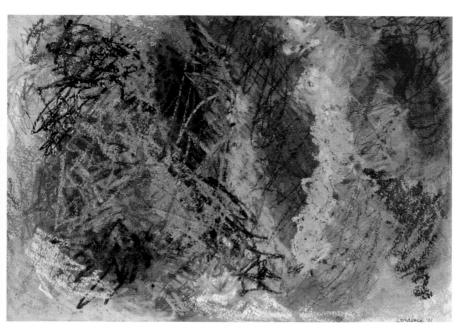

This Way Then That, 2001

ALSO BY NATALIE GOLDBERG

MEMOIR

Long Quiet Highway: Waking Up in America The Great Failure: My Unexpected Path to Truth

POETRY

Chicken and in Love
Top of My Lungs: Poems and Paintings

WRITING BOOKS

Writing Down the Bones: Freeing the Writer Within
Wild Mind: Living the Writer's Life
Thunder and Lightning: Cracking Open the Writer's Craft
Old Friend from Far Away: The Practice of Writing Memoir
The True Secret of Writing: Connecting Life with Language

NOVEL

Banana Rose

NOTEBOOK

Essential Writer's Notebook

DOCUMENTARY FILM

Tangled Up in Bob: Searching for Bob Dylan

(with filmmaker Mary Feidt)

A NOTE ABOUT THIS EDITION

AN EARLIER VERSION of this book was published in 1997 by Bantam, a venerable old publisher. When I was in the ninth grade we read *Ballad of a Sad Cafe* by Carson McCullers and I never got over the story of Miss Amelia, Cousin Lymon, and Marvin Macy. A Bantam rooster was displayed on the spine of the paperback. Sadly, Bantam is recently defunct, but as long as it lasted I was happy my book had the same publisher as Ms. McCullers, to be in the same line-up.

When I was a young girl I also poured over beautiful big books filled with paintings by Monet, Matisse, Manet, Cézanne, Degas, and van Gogh, often in museum bookstores or at my aunt Priscilla's Brooklyn apartment. What does a young girl care about a publisher? A young girl cares about everything. The name Abrams became synonymous for me with art—and, therefore, with happiness. So when I opened my laptop one chilly morning in late October and read that Abrams wanted to republish my book about painting, I could not contain my delight. And even though I was at the tail end of a nasty flu, I jumped around my living room, called my friend in Texas at an indecent hour, and when she didn't answer, called two other friends in California where it was even earlier. I've written a lot of books so I can be blasé when it comes to publishing, but that morning the old heat stirred. Maybe there is continuity in this jagged world, that the moon and stars do align, that what awoke in me early on can come home.

It's not faith, really. What helps more is continuous, quiet practice, accepting the process, not hoping for anything, but noticing how our life and the world unfolds, realizing even though we are busy Google-ing, Tweeting, blogging, Facebooking, stumbling, and tumbling, we can also recognize that publishing, the art of language and line, is an honored tradition that hums along, too, at its own pace.

Please enjoy this book-in whatever form you read it.

Editor: Liana Allday Designer: Mary Jane Callister Production Manager: Tina Cameron Library of Congress Control Number: 2013945658

ISBN: 978-1-61769-084-6

Text and artwork copyright $@\,2014$ by Natalie Goldberg

Artwork on page 1, The Great Spring, 2002, @ Natalie Goldberg

Published in 2014 by Stewart, Tabori & Chang An imprint of ABRAMS.

All rights reserved. No portion of this book may be reproduced, stored in a retrieval system, or transmitted in any form or by any means, mechanical, electronic, photocopying, recording, or otherwise, without written permission from the publisher.

The text of this book was composed in Baskerville 10 Pro, Bulmer, and Omnes.

Printed and bound in the United States. 10 9 8 7 6 5 4 3 2 1

Abrams books are available at special discounts when purchased in quantity for premiums and promotions as well as fundraising or educational use.

Special editions can also be created to specification.

NEW YORK, NY 10011 WWW.ABRAMSBOOKS.COM